MUTTS

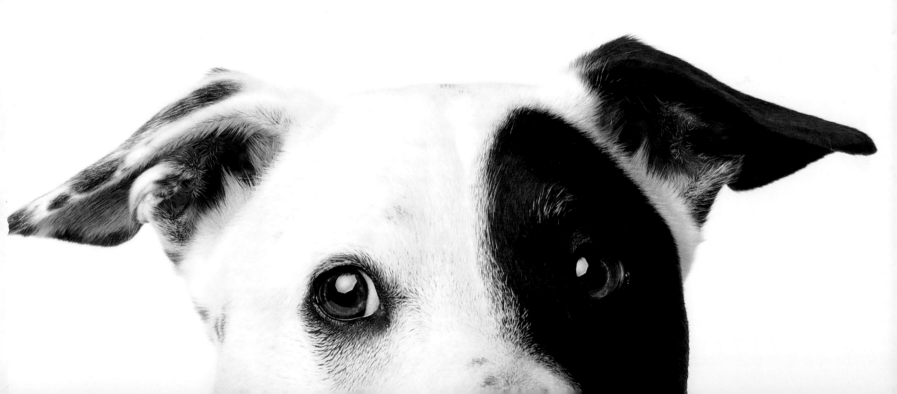

For all our good dogs
Spike, Chester, Gus, Jasper, Hector, Rue, Jack,
Dalton, Midnight, Elly, and Friday

MUTTS

A CELEBRATION OF MYSTERY MIXED BREEDS

WRITTEN AND PHOTOGRAPHED BY
OLIVIA GREY PRITCHARD

SUSAN SCHADT PRESS

Introduction

If you've ever loved a bona-fide mutt, you know that they're some of the best, most loyal dogs ever. This body of work is a celebration of mystery mixed breeds. The dogs featured within **MUTTS** are photographed in my portrait studio in New Orleans, and they speak for mutts all over the world. Each photograph is accompanied by the pup's name and best guess of breed mix – as well as one fun or interesting trait about them. I like to think of it as their dating profile header. I want people to feel joy and connection when they look through this book, and for people who haven't considered a rescue pet before, I'd love for them to see that mutts have just as many inimitable, lovable, and desirable qualities as pedigreed dogs.

There are so many unique challenges for a photographer working with animals, especially animals that are not specially trained, and who often have had traumatic experiences in their past. For example, some dogs were scared of the flash, so we had to adjust the lighting for them. Some dogs didn't like the feel of the backdrop under their paws, so we put down a special mat for them to sit on. I was armed with an amazing dog handler, lots of treats, and every dog toy imaginable. I scheduled six dogs a day, each in hour slots, every day for weeks; some dogs were done in ten minutes, while some needed the full hour. The key was to be as patient, flexible, and calm as possible, because both the dogs and their owners fed off the energy of my dog handler and me. Literally every dog was different and required a slightly different approach, both technically (with lighting, lens, and the focal length choice that would best show off their distinctive traits) and emotionally (some dogs

needed half an hour to sniff around and become comfortable, while some were immediately willing to do whatever we asked for a treat). One might think that two large, white dogs could easily be photographed in the same lighting – but the reality is that every fur texture and color reflects light differently, so every single subject required dialed-in lighting custom to their coats. Getting this book shot in two months was incredibly fast-paced and intense, but also joyful: seeing so many dogs everyday was gleeful in and of itself, but hearing their stories and seeing how much their families loved them was incredibly uplifting.

I've been enormously lucky to have had mutts my whole life, including a border collie mix named Spike whom my mom found as a puppy, long before I was born, trying to lick the last drops out of a milk carton... a husky mix named Wylie who met my school bus every afternoon, but whom we had to rehome because he needed more space to RUN, RUN, RUN... the most loyal hound/shepherd mix named Chester who came with a bum leg and loved to sun himself in a certain spot in the front yard. All pretty big dogs, and all rescues. My current rescue mutt, Jasper, is a 120 pound St. Bernard/retriever/shepherd mix who *loves* chasing squirrels and cats, but somehow instinctively knows that the mini-bunny hopping around the house is off-limits for eating, and the human baby who arrived two years ago doesn't mean to smack him when she "pets" (the constant sharing of snacks and dropping food on the floor has gone a long way towards fostering that relationship). I am so grateful my daughter is growing up with a big dog who is patient, tolerant, and teaches her how to be gentle and kind to animals.

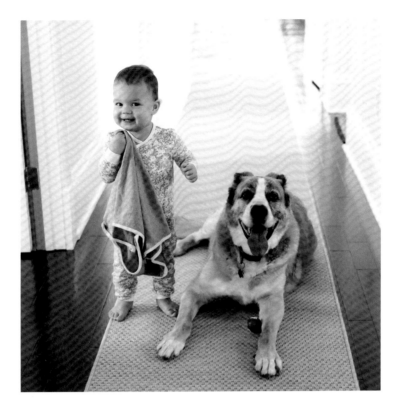

Lulu and Jasper, 2021

Approximately 670,000 dogs are euthanized in U.S. shelters each *year* (ASPCA). Over half a million dogs (and even more cats, but that's a different book). That statistic is heart-breaking and chilling. So, in addition to fostering more love for mutts, a portion of the proceeds from this book will be donated to organizations who rescue and spay/neuter, locally that include Take Paws Rescue, Animal Rescue New Orleans, Zeus' Place, Greta's Ark Animal Rescue, Trampled Rose Rescue, and the LASPCA.

I hope readers will be able to see how much heart and soul that mutts have. My goal is that these portraits will convince people looking to buy a dog that it's worth at least walking through their local shelter to see if they get that instant, karmic connection with a dog who needs a home and is in danger of being euthanized. Every person who adopts a shelter dog saves more than one life: they're also saving the life of the next dog they just made space for at the shelter. And it's been my experience that rescue dogs are the most loyal dogs, maybe because they are so grateful for their second chance.

I hope everyone gets to experience the joy of saving a life by rescuing a shelter pet. Dogs are a study in forgiveness, in letting go of the past, and living in the moment. We can all learn from them.

—Olivia Grey Pritchard

Joe DACHSHUND / BLUETICK COONHOUND

Can smell chicken from three blocks away

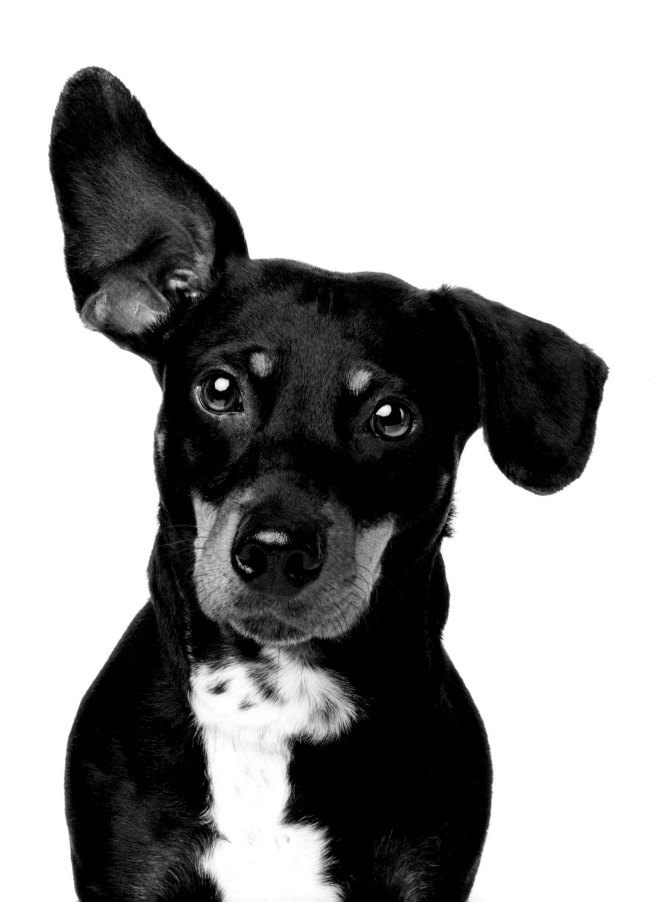

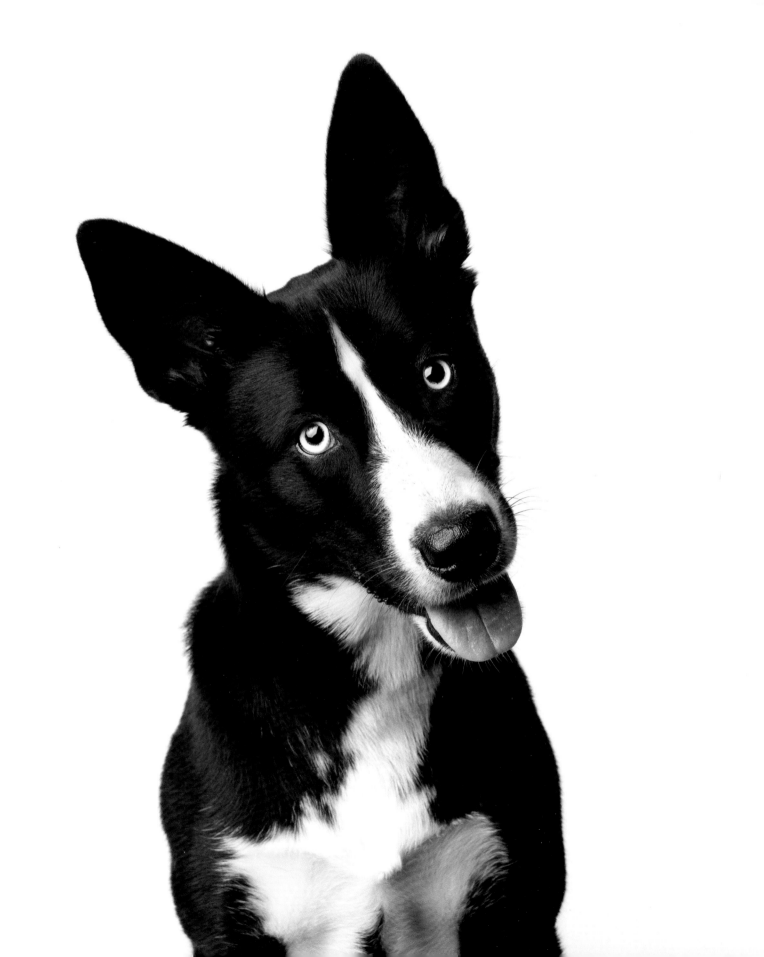

Mika SIBERIAN HUSKY / AMERICAN BULLY / MASTIFF

Loves ice and broccoli

Rosie TERRIER / AUSTRALIAN SHEPHERD

Prances like a fox

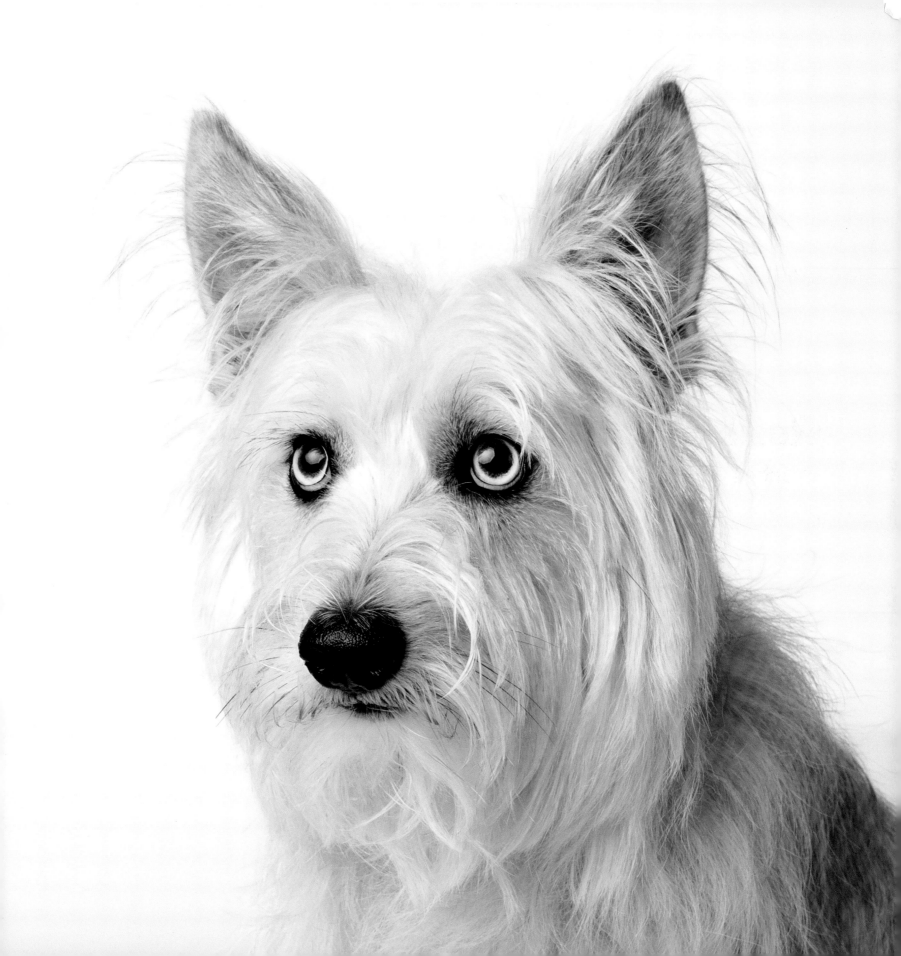

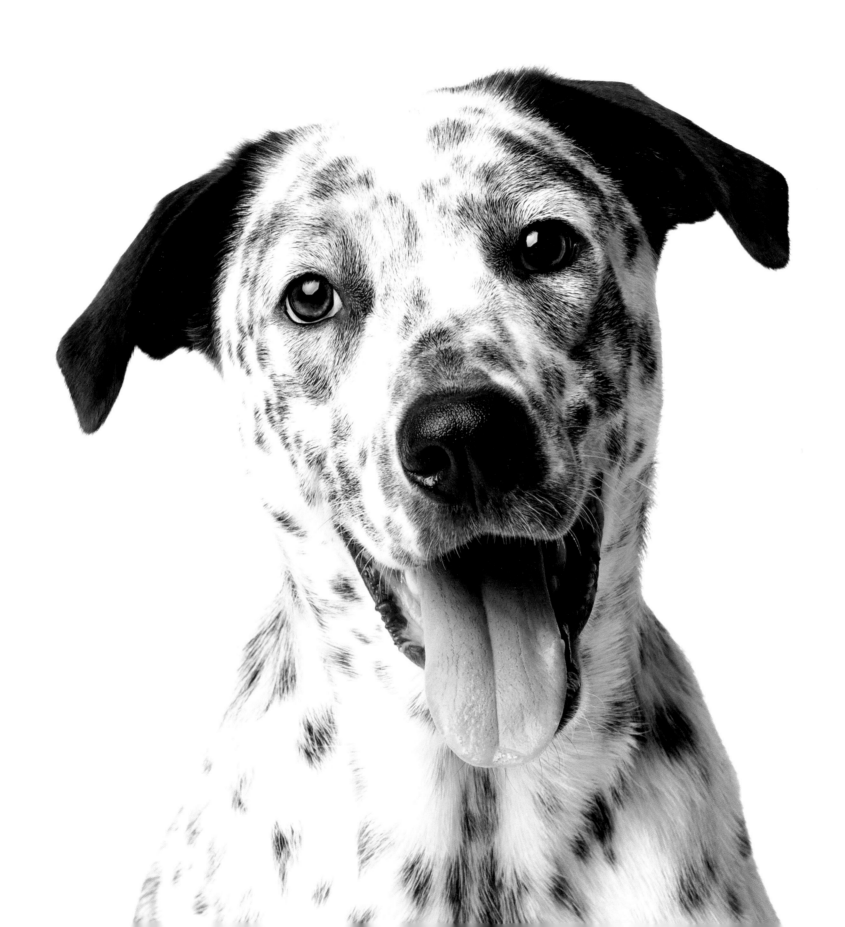

Bogie DALMATIAN / AUSTRALIAN SHEPHERD / AUSTRALIAN CATTLE DOG

Eats shoelaces, but only if the shoes are being worn at the time

Ferb FRENCH BULLDOG / CATAHOULA LEOPARD DOG

LOVES chickens; they are friends

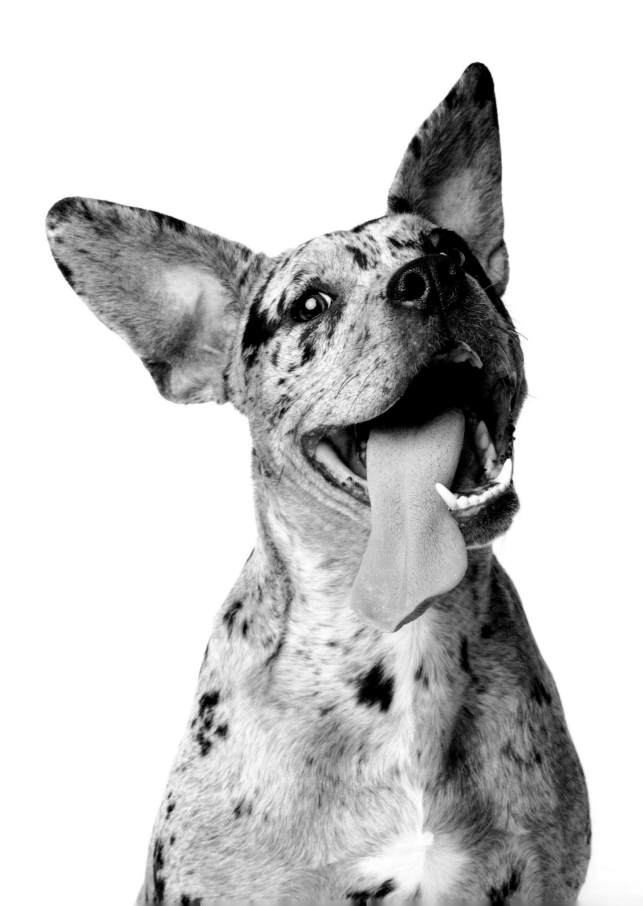

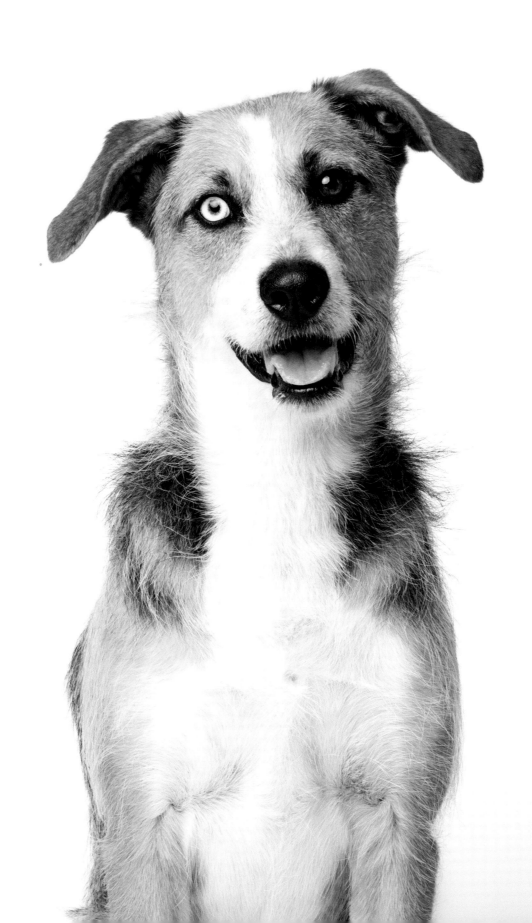

Atlas CATAHOULA LEOPARD DOG / TERRIER

Deeply afraid of chickens and balloons

Evie CATAHOULA LEOPARD DOG / LABRADOR RETRIEVER

Doesn't allow any talking after bedtime lights out

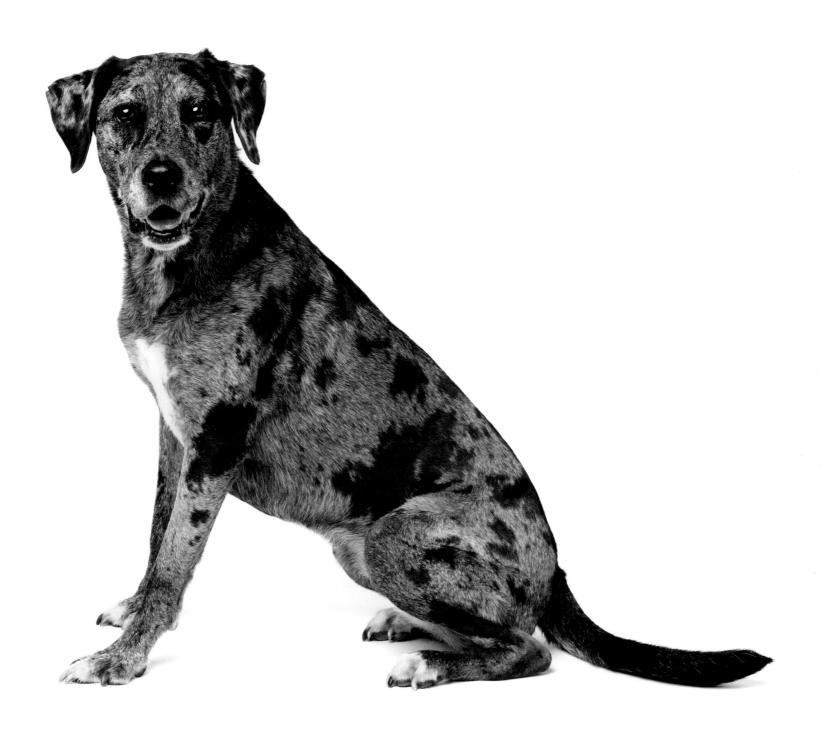

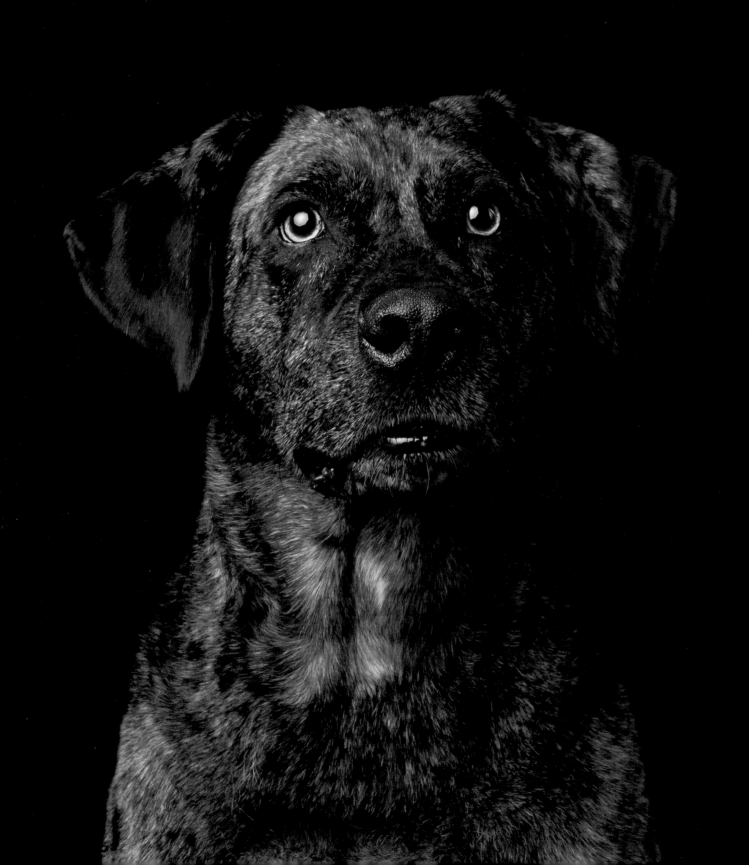

Gunner WEIMARANER / CATAHOULA LEOPARD DOG / LABRADOR RETRIEVER

Loves swimming, hates baths

Lana AMERICAN STAFFORDSHIRE TERRIER / BLUE HEELER

Is so sweet that her foster mom became her furever mom

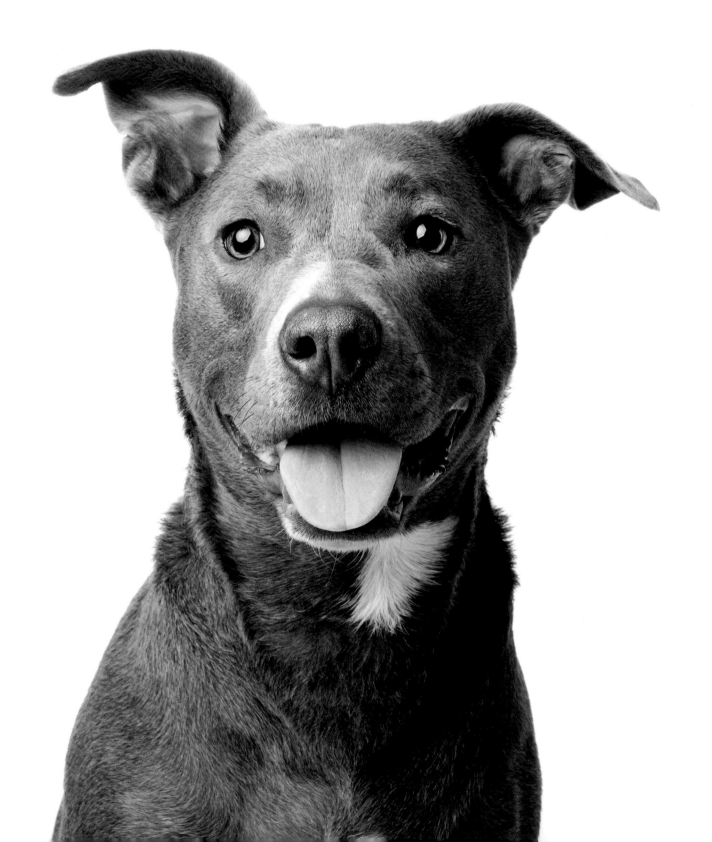

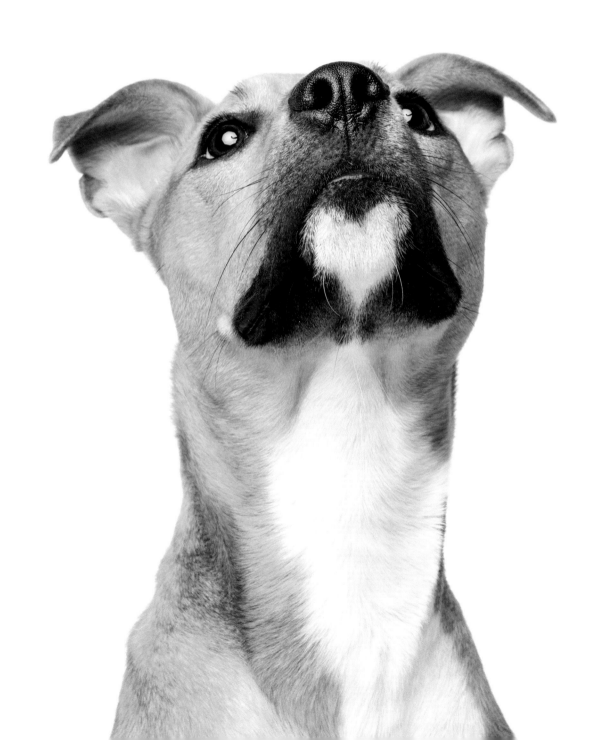

Lillie AMERICAN BOXER / BLACK MOUTH CUR

Steals whatever you put in the toaster...directly from the toaster

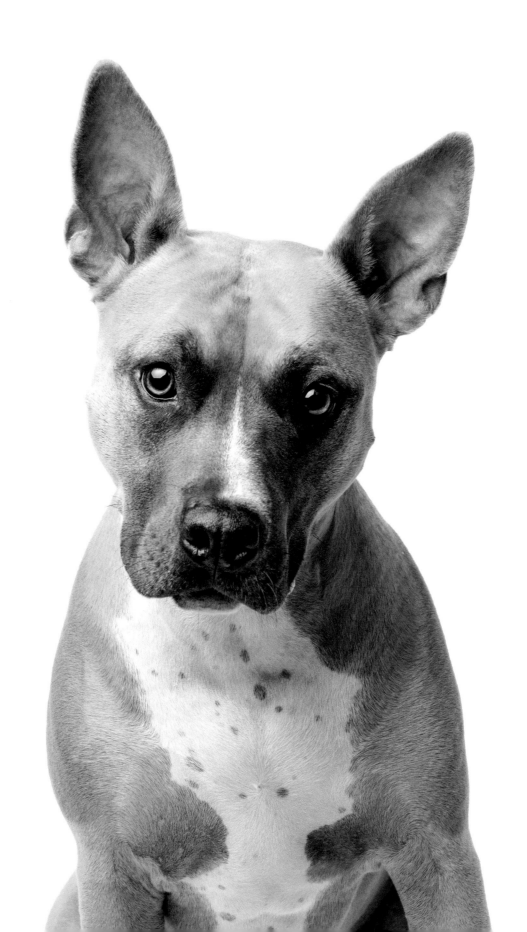

Celeste AMERICAN PIT BULL / GERMAN SHEPHERD / STAFFORDSHIRE TERRIER

Loves to watch dogs in movies

Paisley AUSTRALIAN SHEPHERD / BORDER COLLIE

SQUIRREL

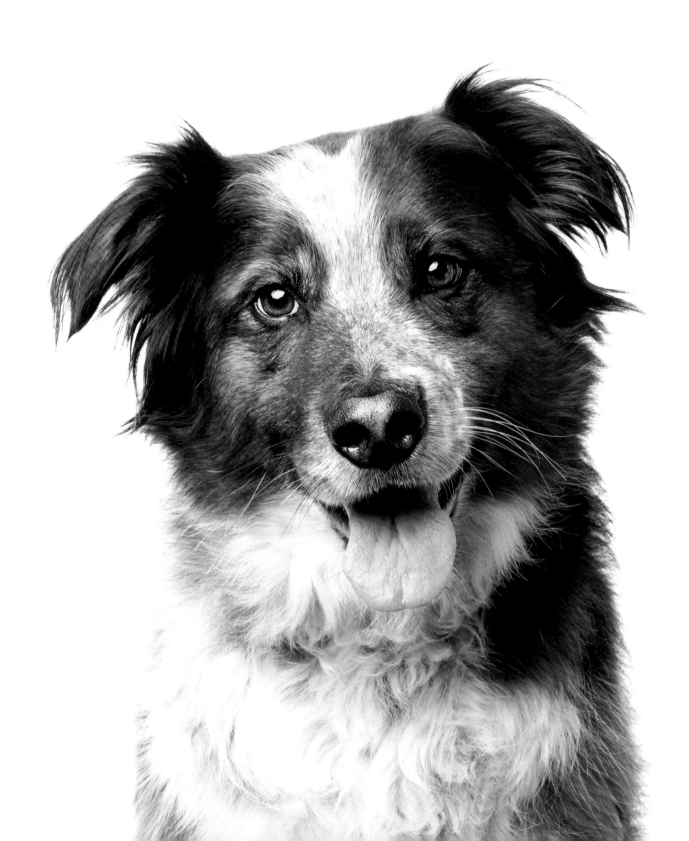

Moose ROTTWEILER / PIT BULL TERRIER

Rolls over and gives very effective sweet eyes
when you use a stern voice

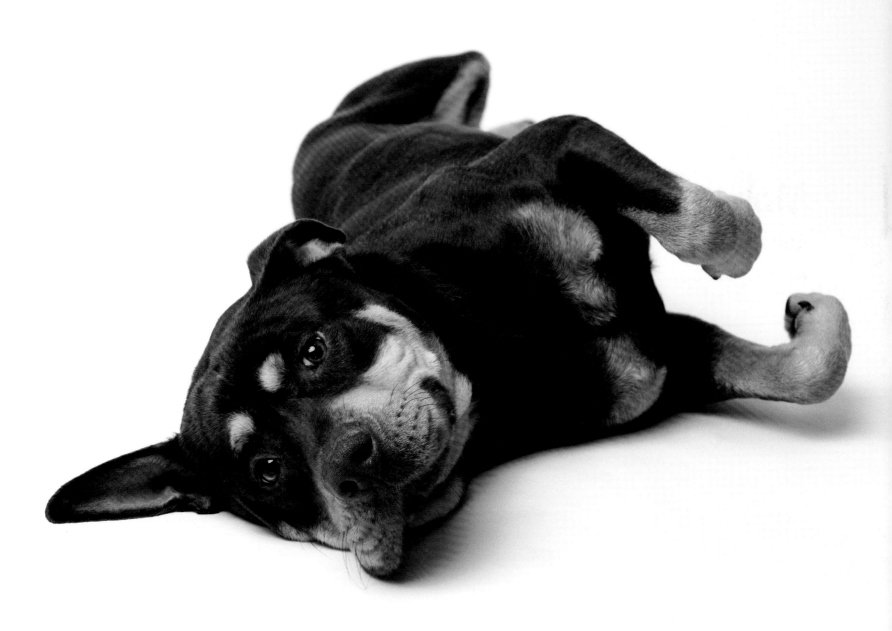

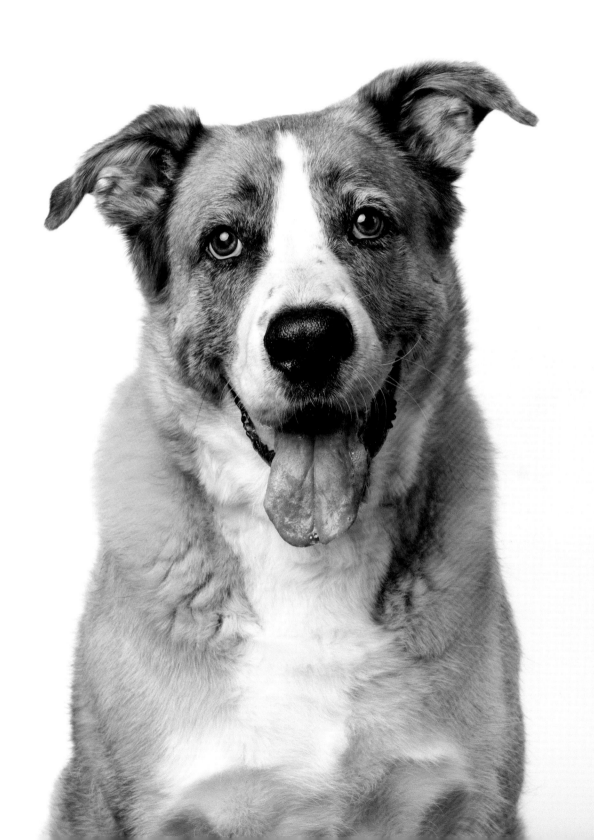

Jasper SAINT BERNARD / LABRADOR RETRIEVER / GERMAN SHEPHERD

Walks backwards through doorways
(he's not superstitious, but he's a little stitious)

Bean GREAT DANE / ENGLISH MASTIFF / ROTTWEILER

Loves accessories, has curated her own scrunchie collection

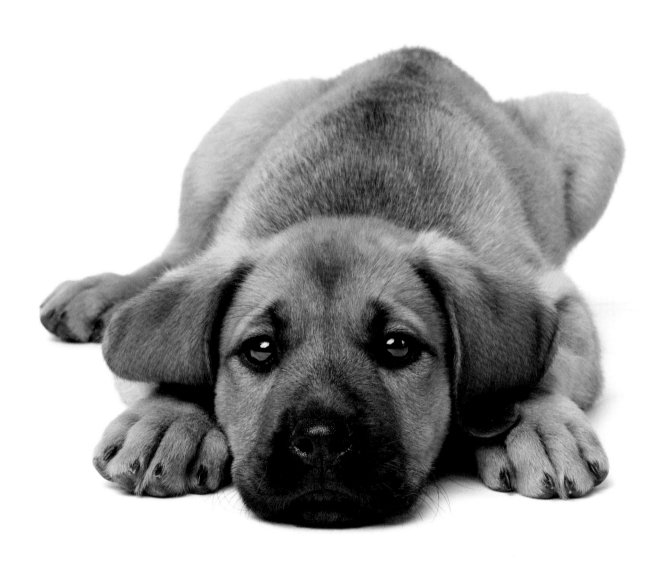

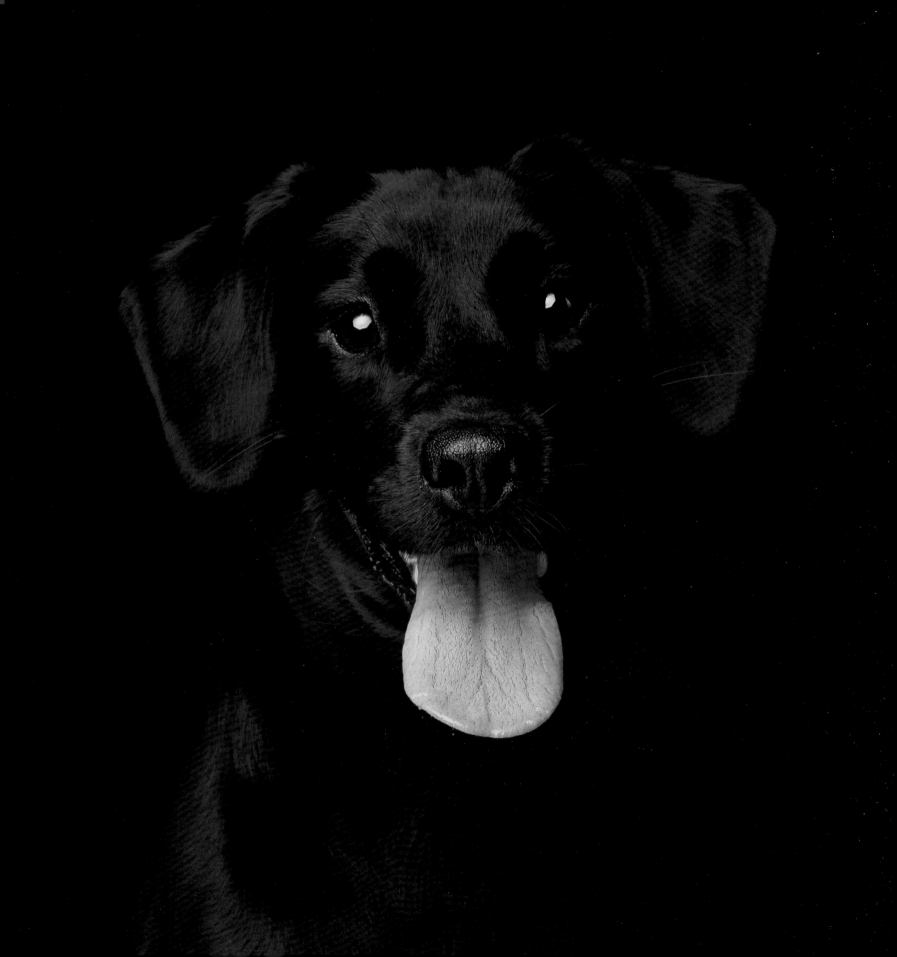

Holly BLACK LABRADOR / CHIHUAHUA

Really wants to follow commands, but sometimes she's just SO EXCITED

Marmaduke DACHSHUND / ALASKAN KLEE KAI

Sings, definitely a soprano

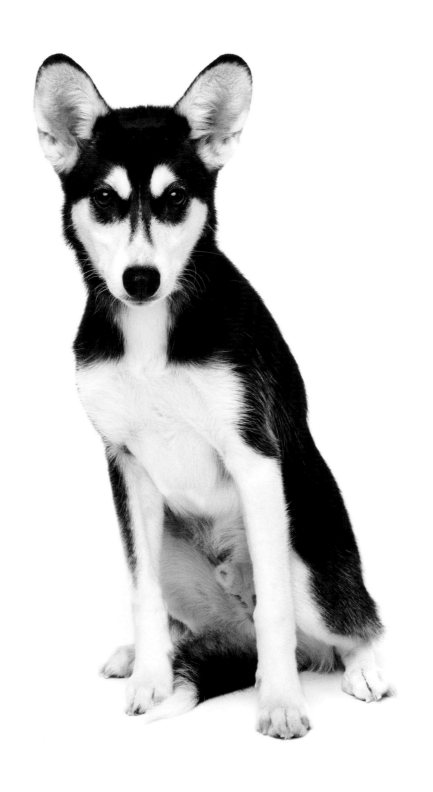

Filé AMERICAN PIT BULL / AMERICAN STAFFORDSHIRE TERRIER

Toy hoarder

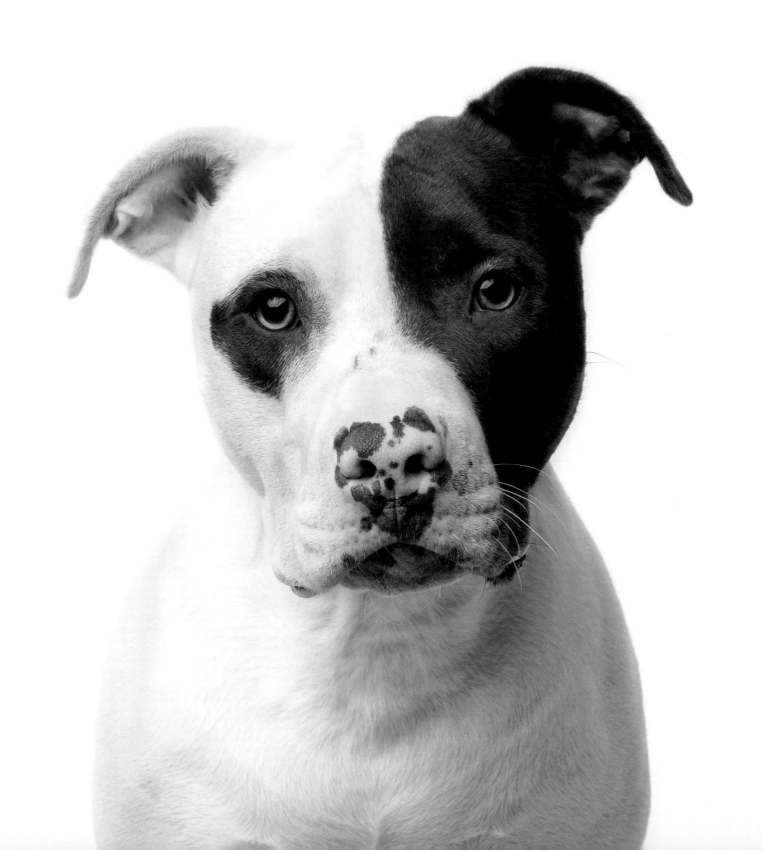

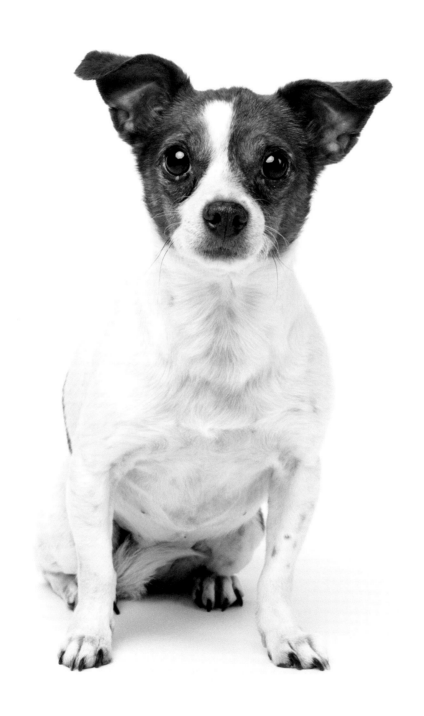

Lulu JACK RUSSELL TERRIER / CHIHUAHUA

Lizard assassin

August ENGLISH POINTER / RED HEELER

Always grabs a toy to go

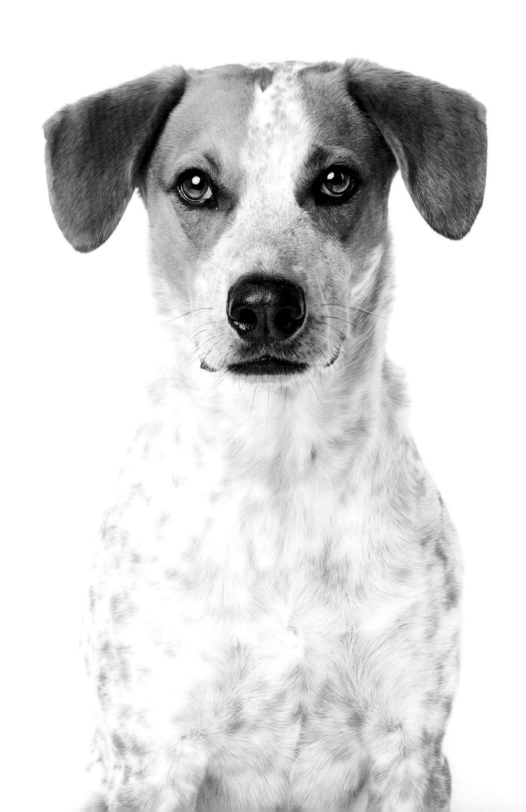

Bear WOOLY SIBERIAN HUSKEY / GREAT PYRENEES

Huge, stubborn... good luck moving him off the floor AC vent

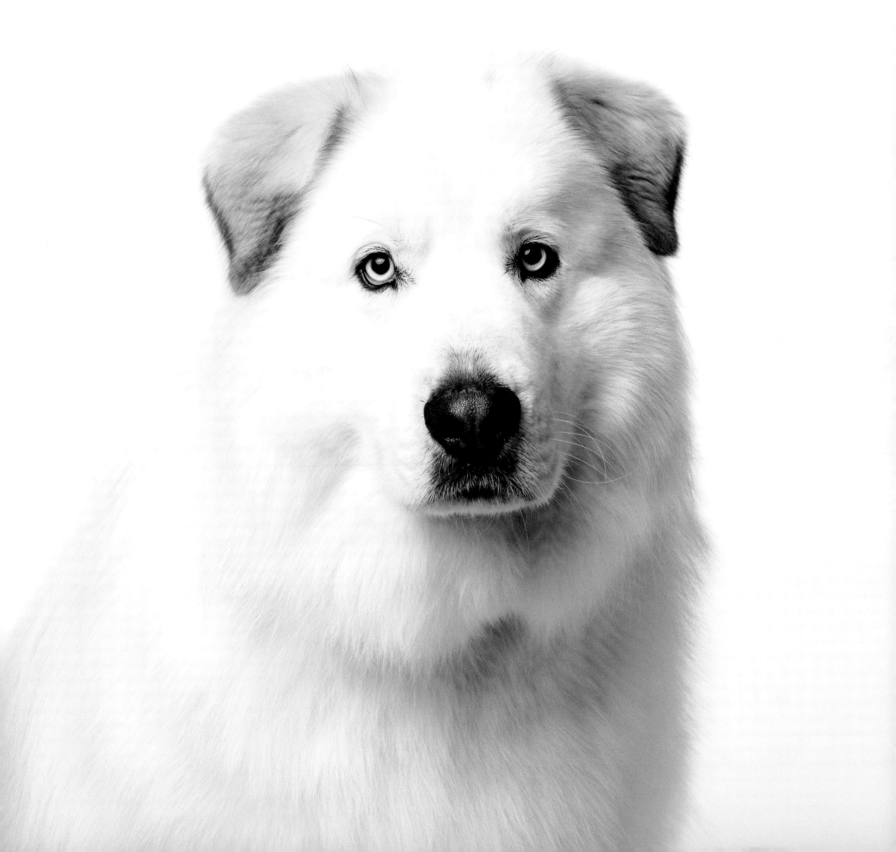

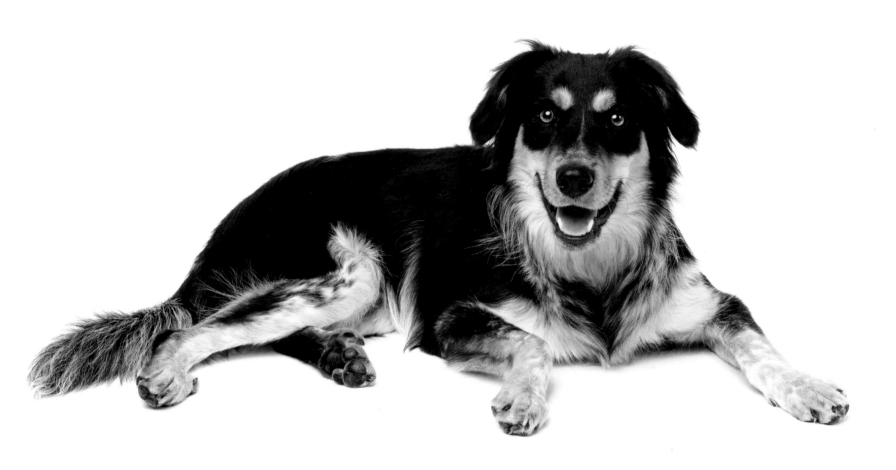

Boss AUSTRALIAN CATTLE DOG / AUSTRALIAN SHEPHERD

Snaps his teeth like an alligator when he's mad, happy, excited, impatient

Jackie BELGIAN MALINOIS / AUSTRALIAN SHEPHERD / LABRADOR RETRIEVER

Never met a stick she didn't like

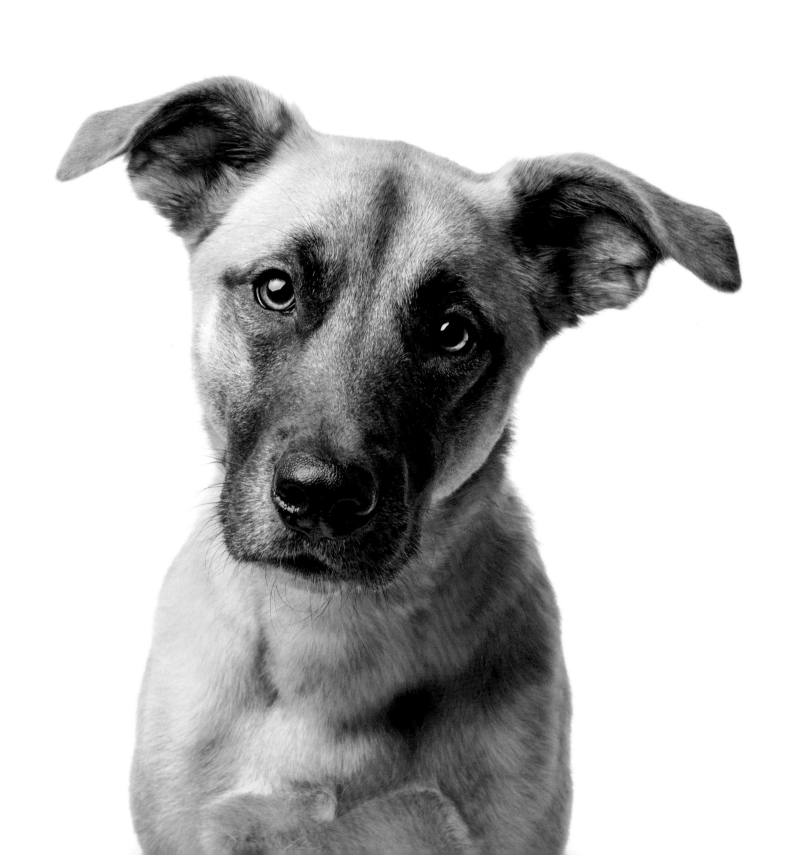

Mahli BORDER COLLIE / AUSTRALIAN SHEPHERD

Sleeps on her back with her paws in the air

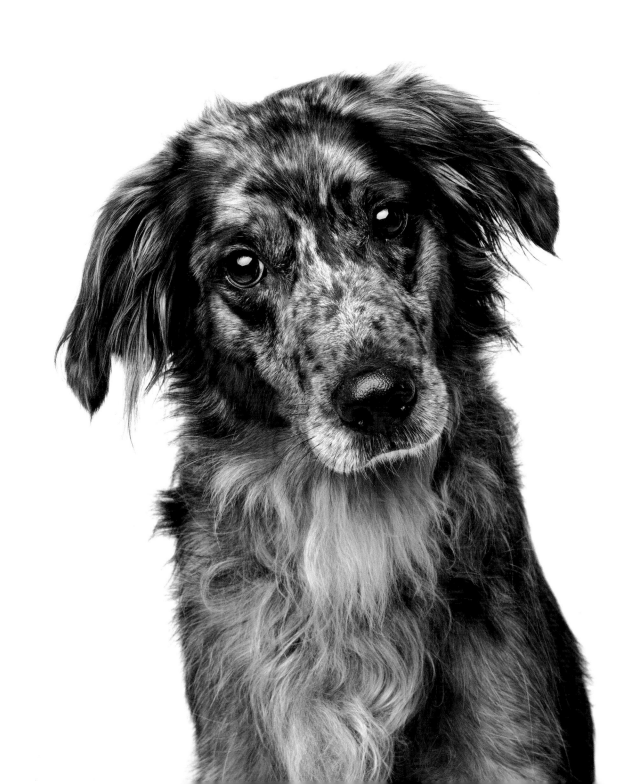

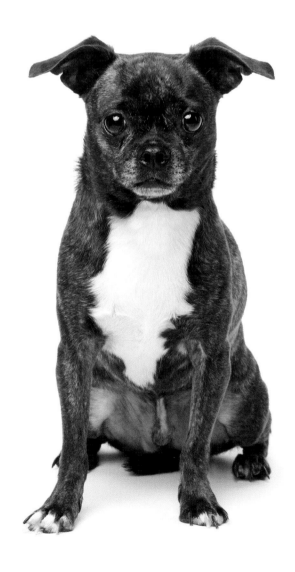

Roco BOSTON TERRIER / CHIHUAHUA

Squirms and slithers on his belly like a snake

Max PIT BULL / HOUND / BULLDOG / RHODESIAN RIDGEBACK

Eats anything…absolutely ANYTHING

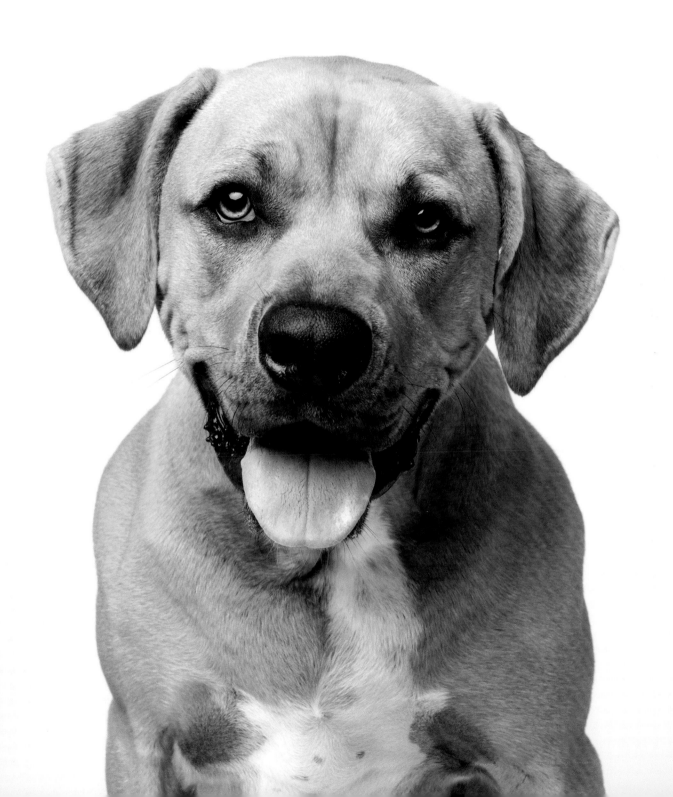

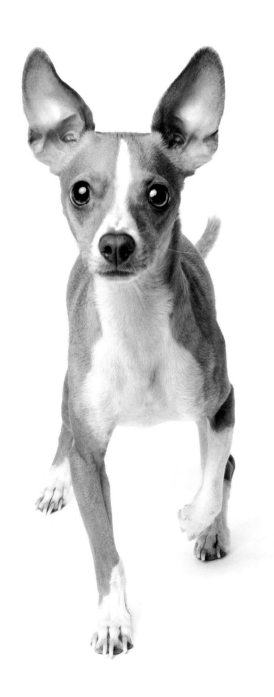

Elvis CHIHUAHUA / BASENJI

Passionately dislikes UPS and FedEx trucks

Chicory ENGLISH POINTER / DOBERMAN PINSCHER

Farts audibly

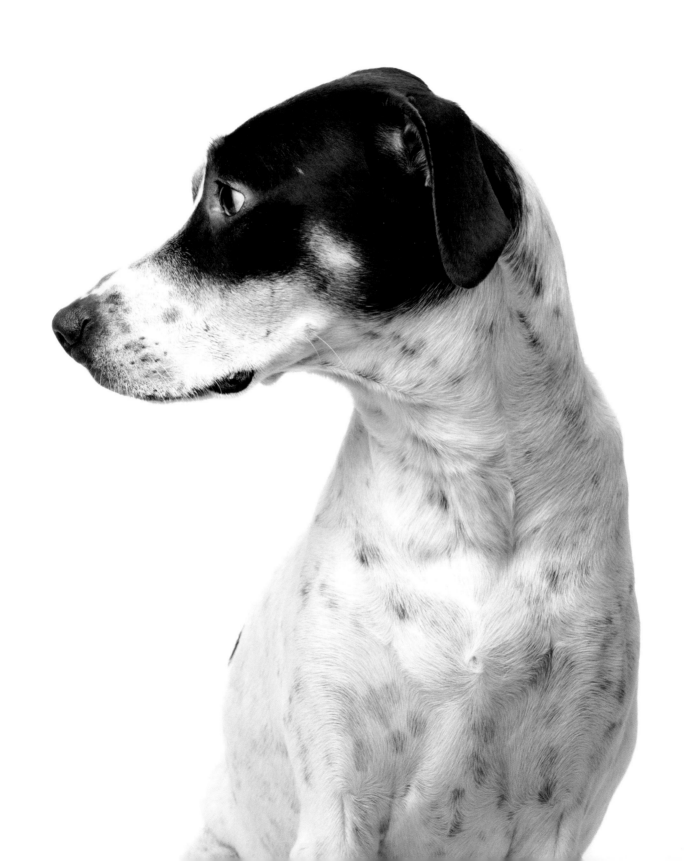

Kuzko GERMAN SHEPHERD / BORDER COLLIE

Likes his yard tidy, demands that you pick up fallen branches and leaves immediately

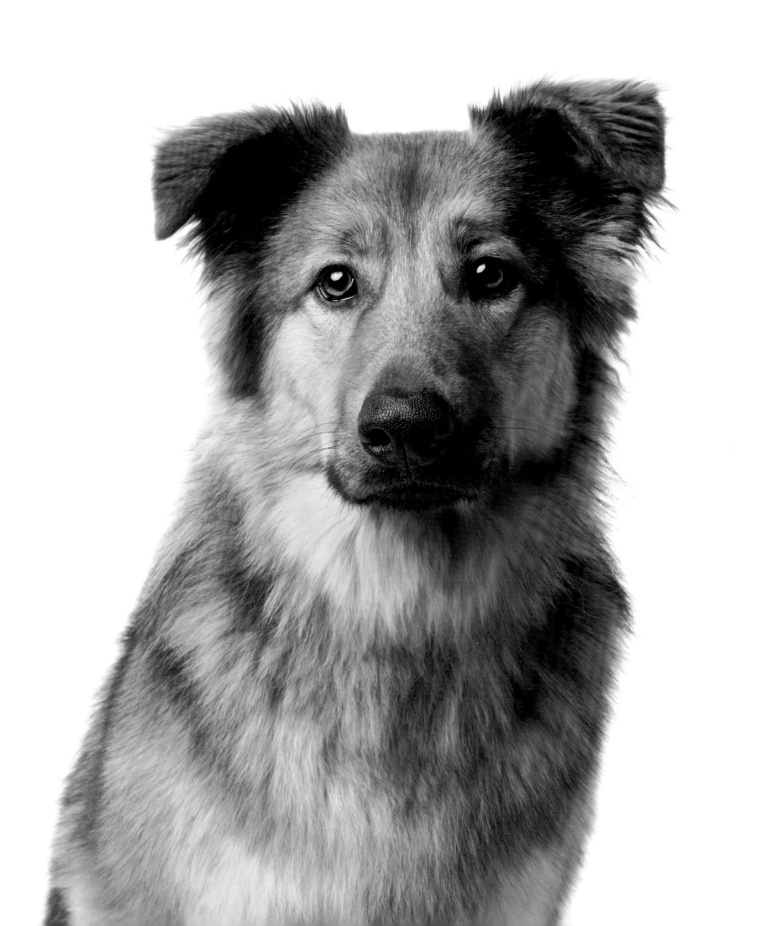

Wilbur AMERICAN STAFFORDSHIRE TERRIER / AMERICAN PIT BULL / AMERICAN BOXER

Looked like a bald, pink little piglet at birth

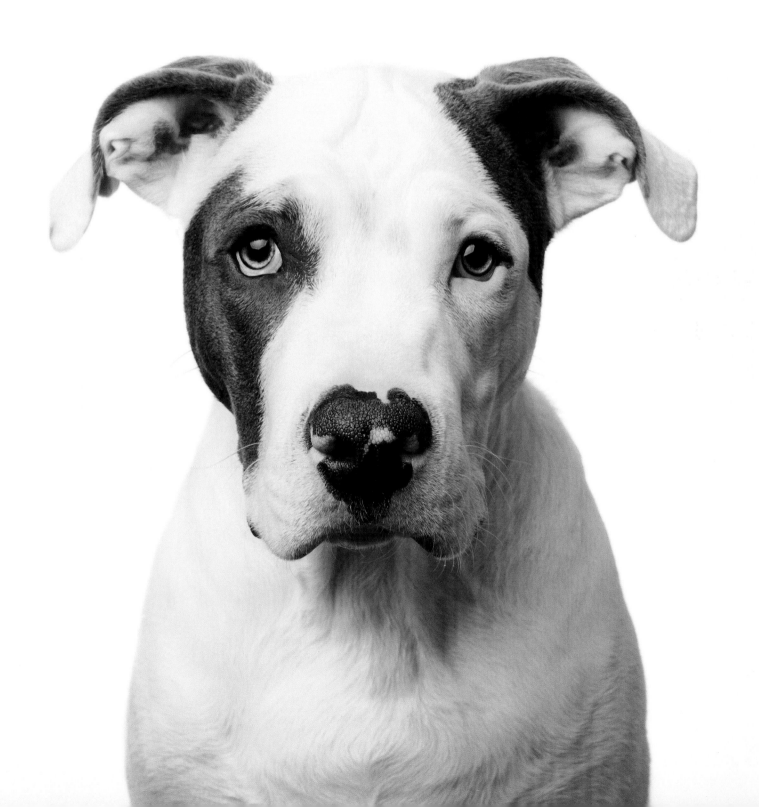

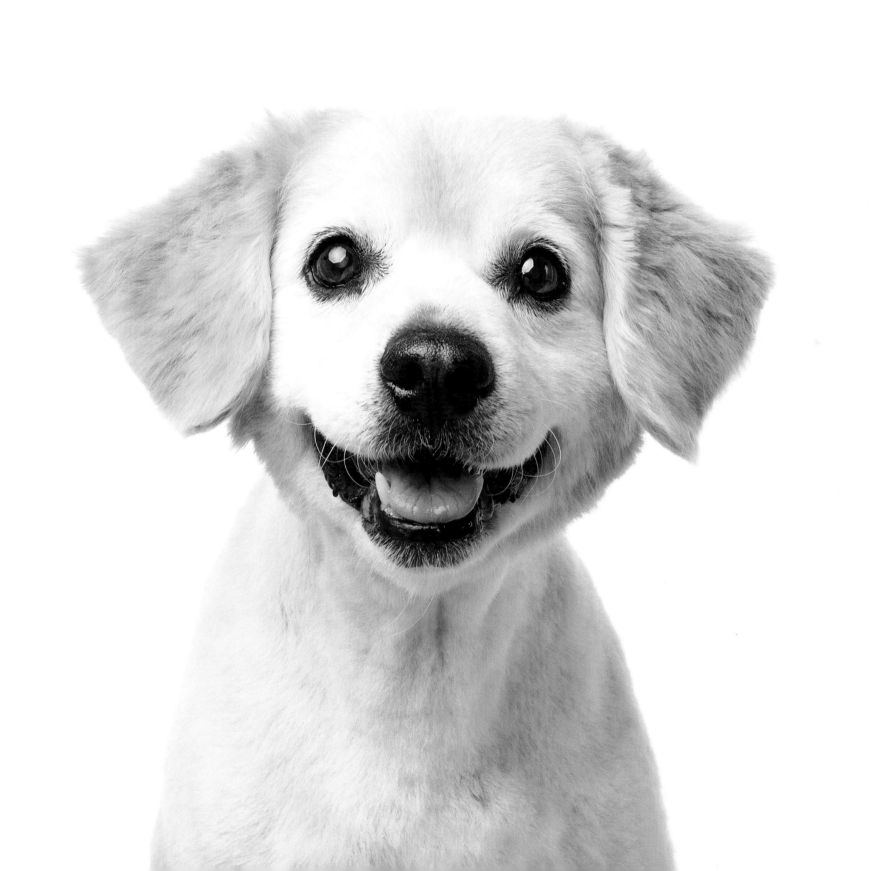

Domino CHOW CHOW / LABRADOR RETRIEVER
AKA "The Vacuum Cleaner"

Lucy Lou ALASKAN MALAMUTE / GERMAN SHEPHERD / SIBERIAN HUSKY

Bounces like a bunny

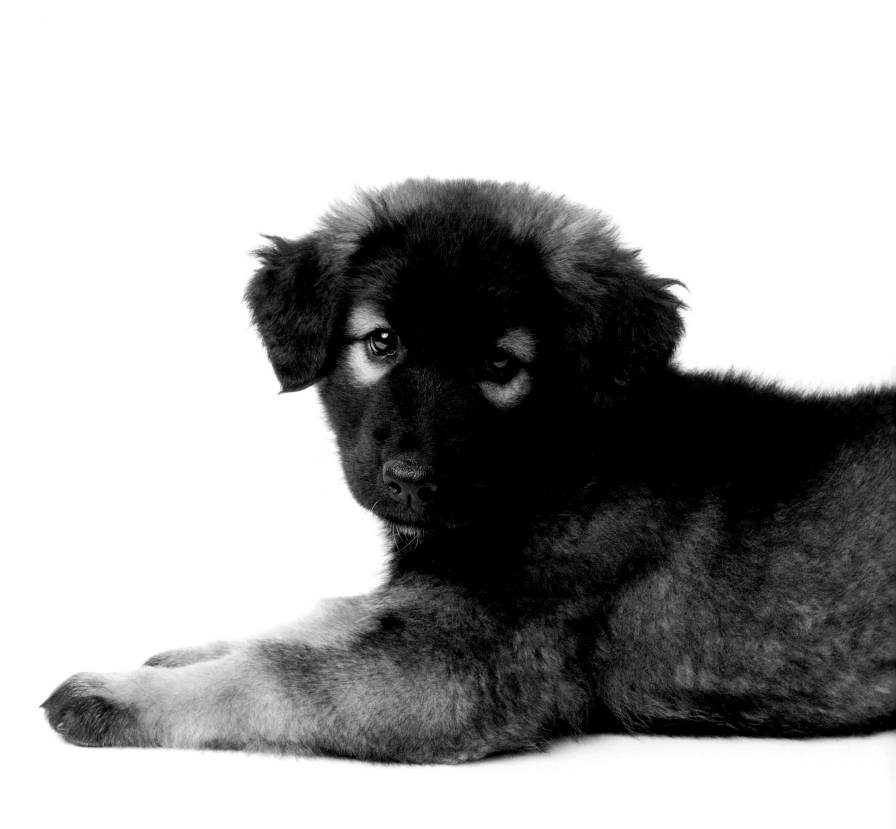

Mango SHAR PEI / LABRADOR RETRIEVER

Sits on one side with his hip splayed out

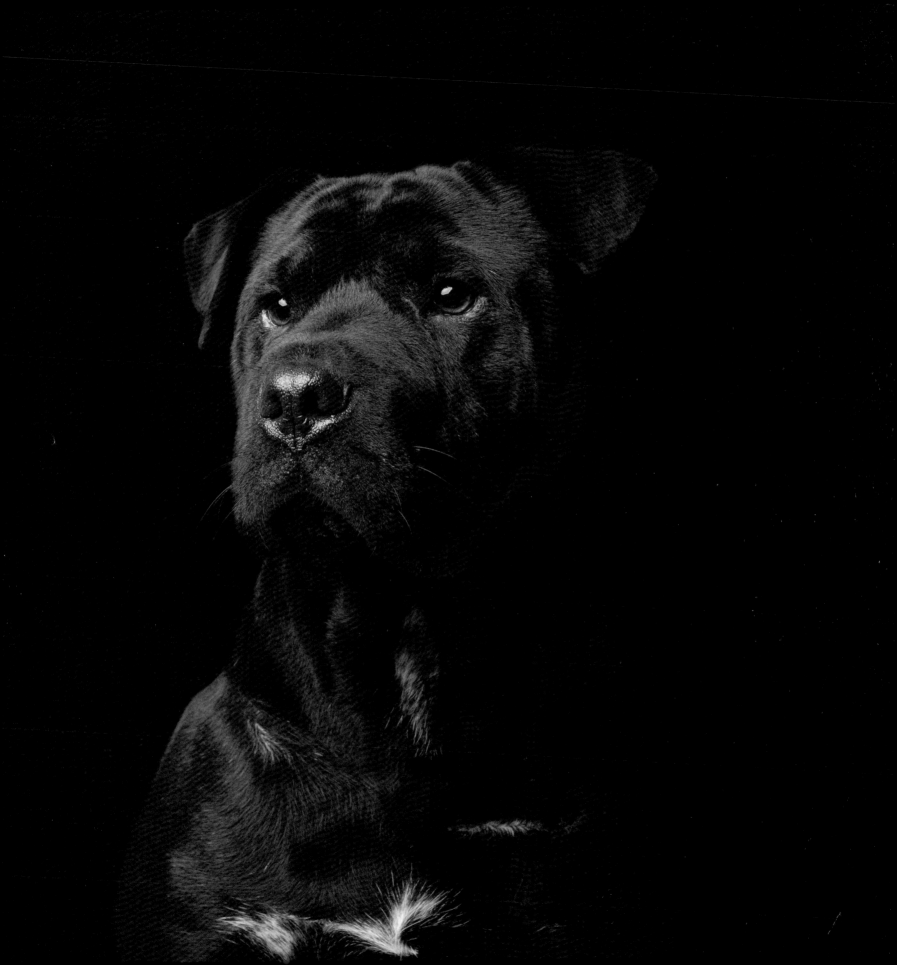

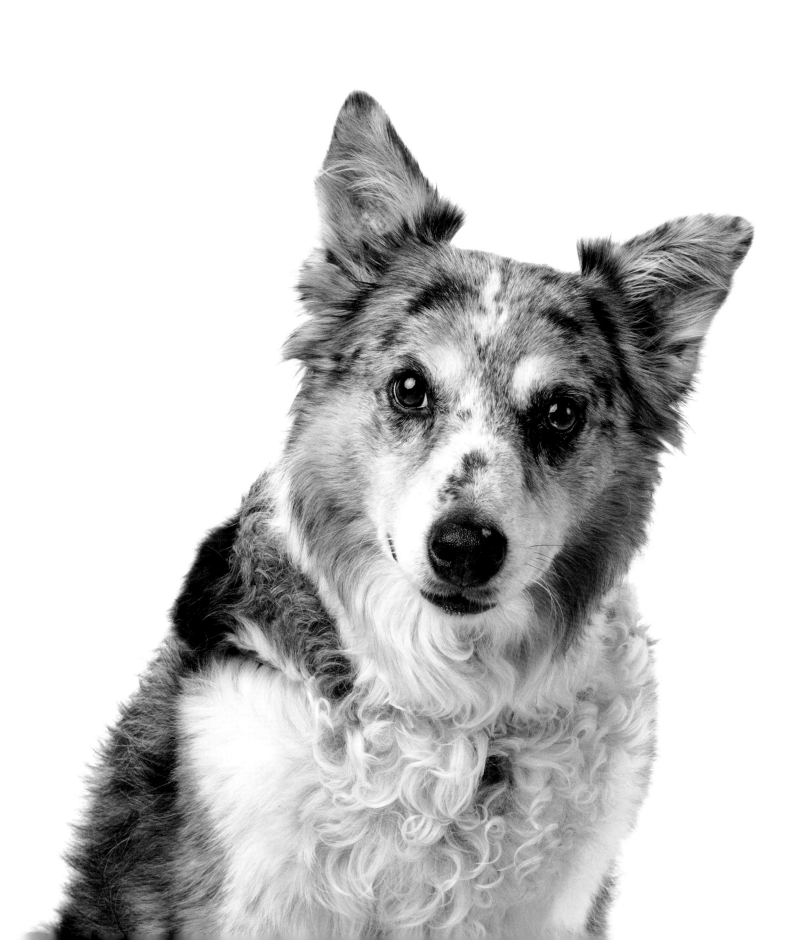

Gigi AUSTRALIAN CATTLE DOG / AUSTRALIAN SHEPHERD

Enjoys boating and jet skiing

Huey CHIHUAHUA / MINIATURE PINSCHER

Barks at everyone, including his family

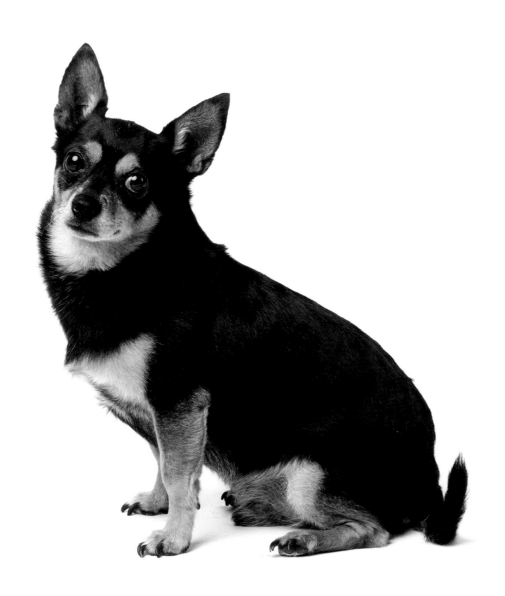

Bella MINIATURE DACHSHUND / MINIATURE PINSCHER

Very caring and kind to everyone

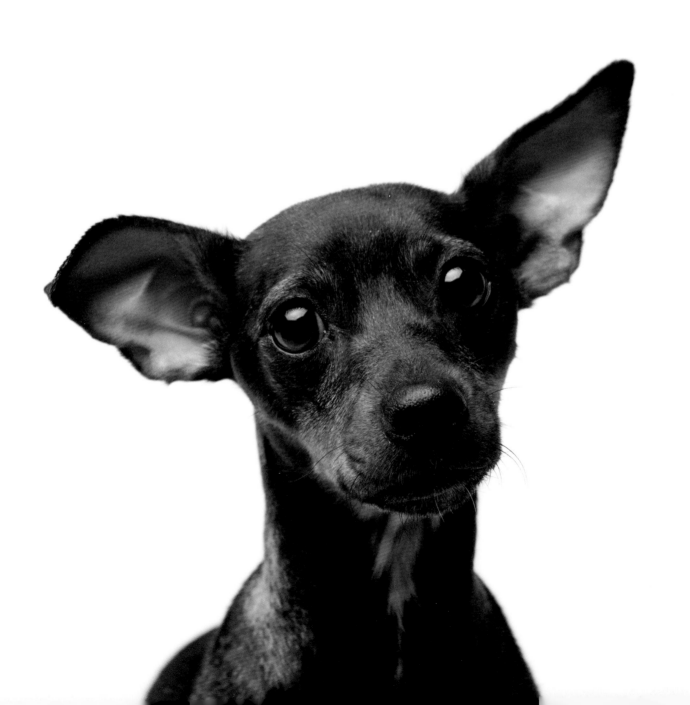

Bella & Puppies MINIATURE DACHSHUND / MINIATURE PINSCHER

Loves her puppies, tired of nursing

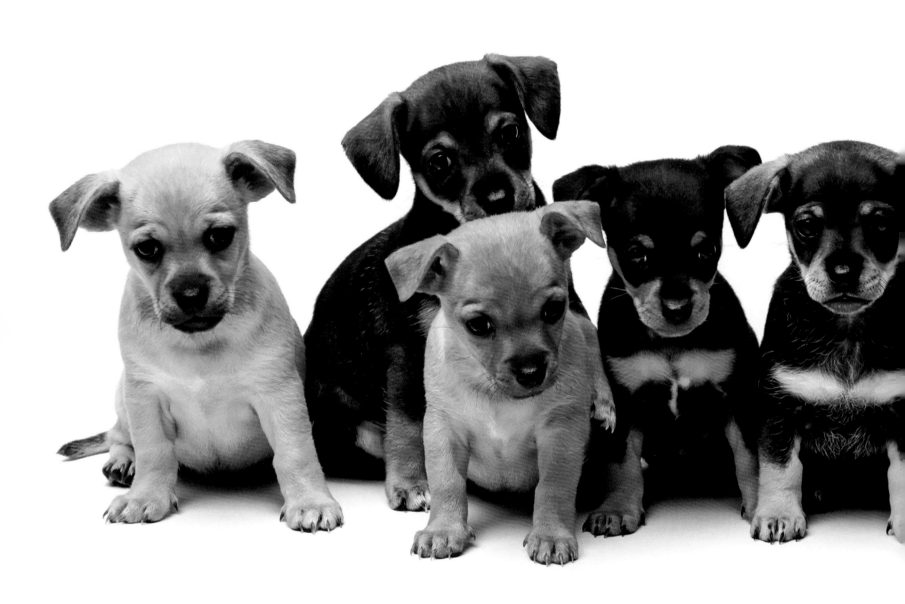

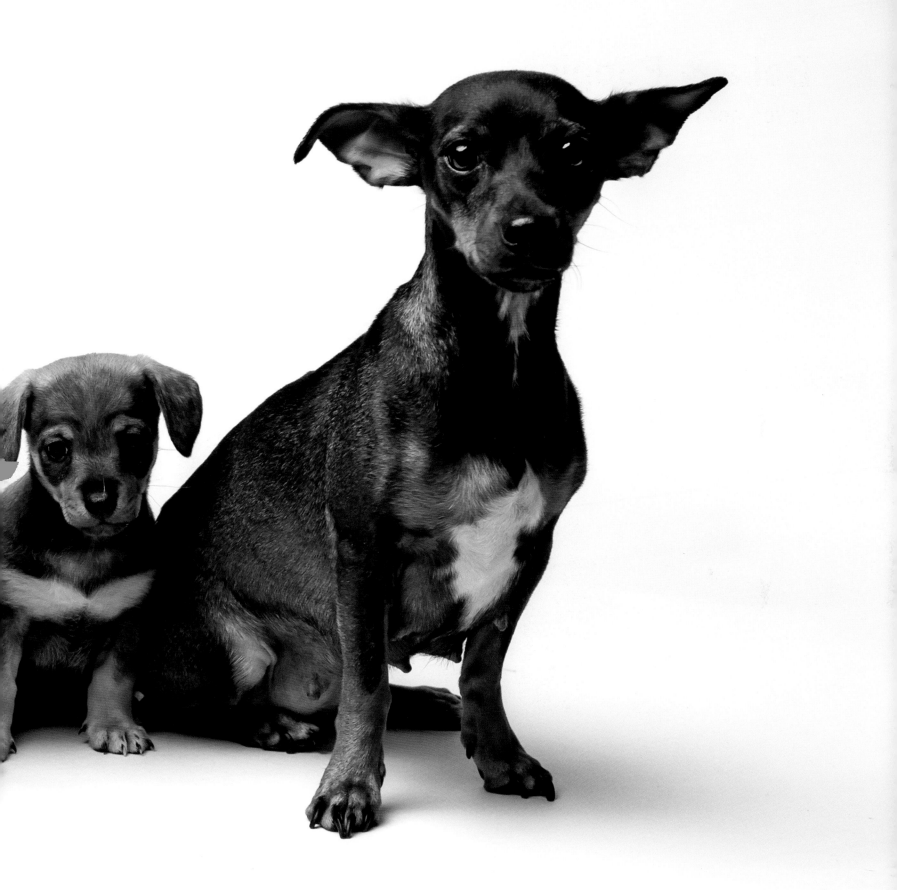

Raki MINIATURE SCHNAUZER / WIREHAIRED FOX TERRIER

Basically a cat

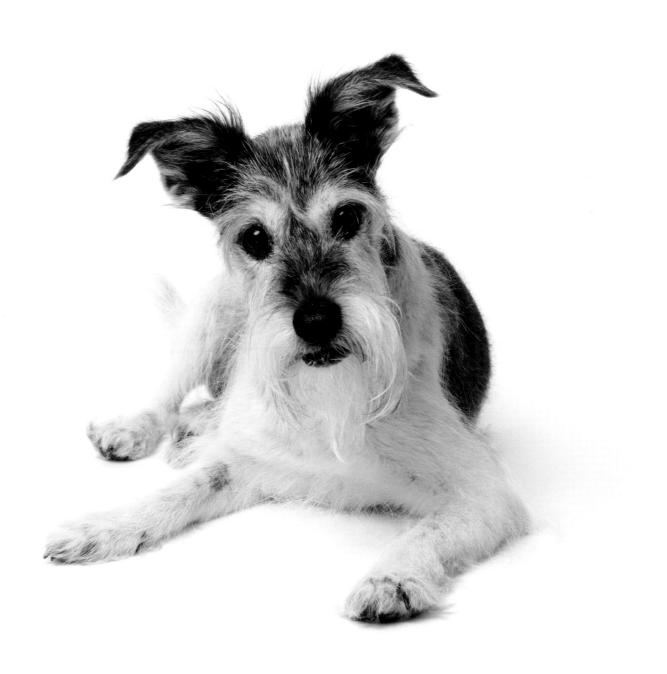

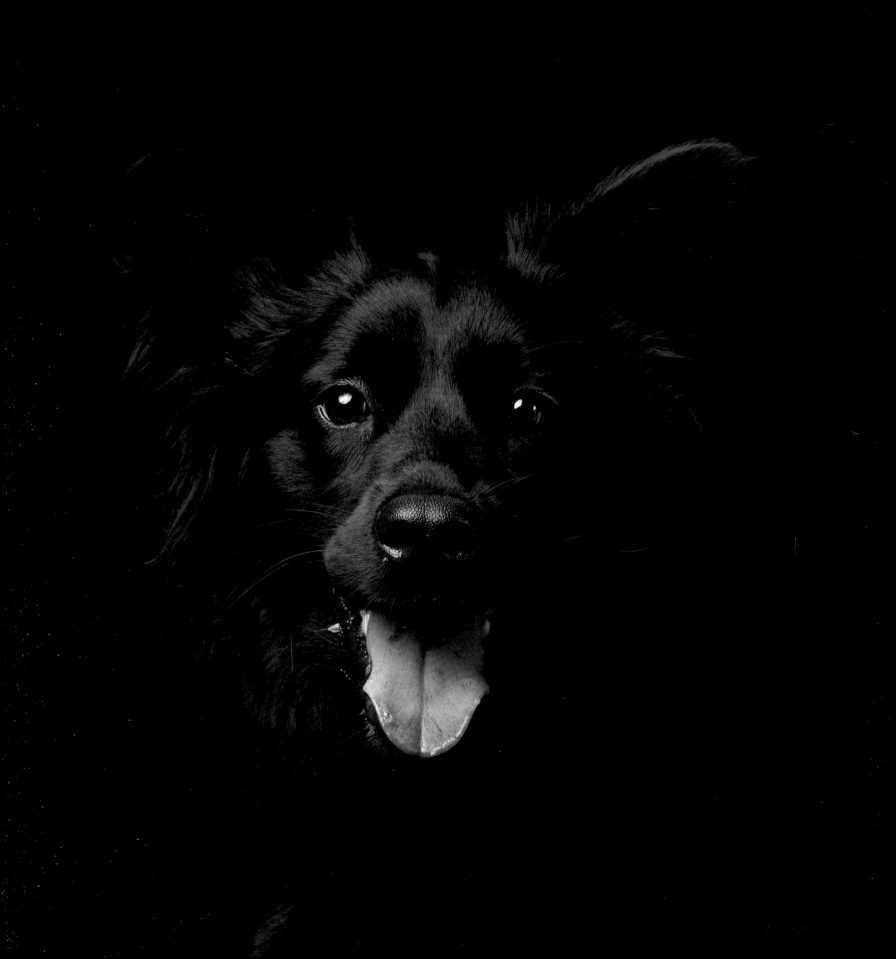

Lemon CHOW CHOW / SHETLAND SHEEPDOG

Very chatty when she wants to play or eat

Danny Rand SHAR PEI / GERMAN SHEPHERD

Jumps for treats

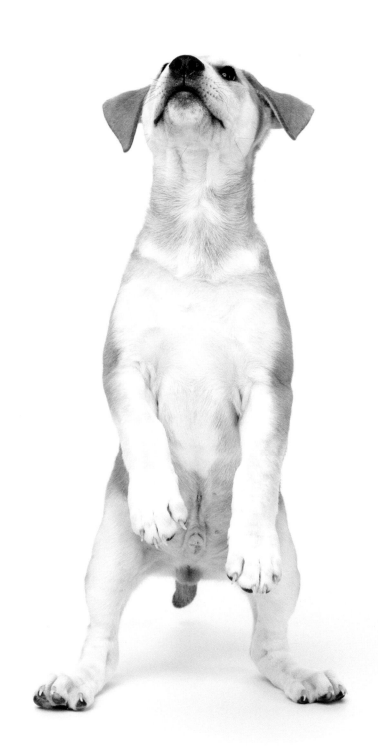

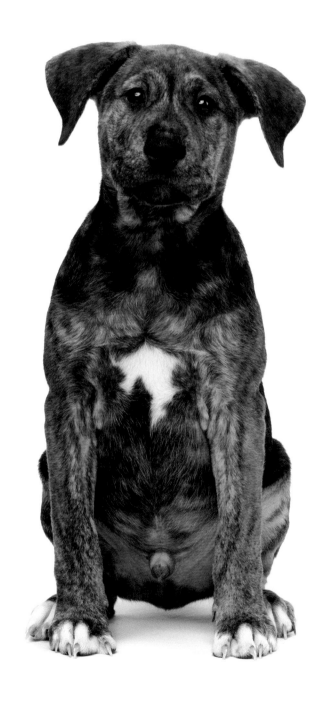

Matt Murdoch SHAR PEI / GERMAN SHEPHERD

Sits pretty for treats

Gumbo NEWFOUNDLAND / GREAT PYRENEES / LABRADOR RETRIEVER
Chomps on carrots like *Bugs Bunny*

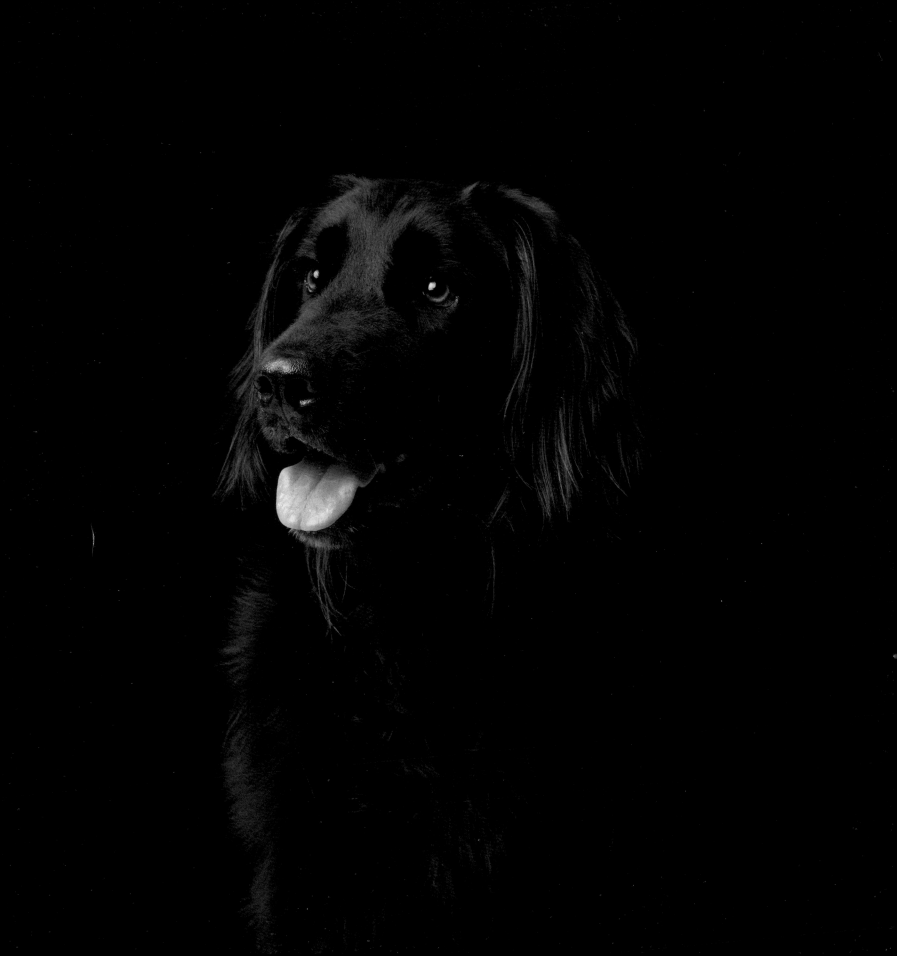

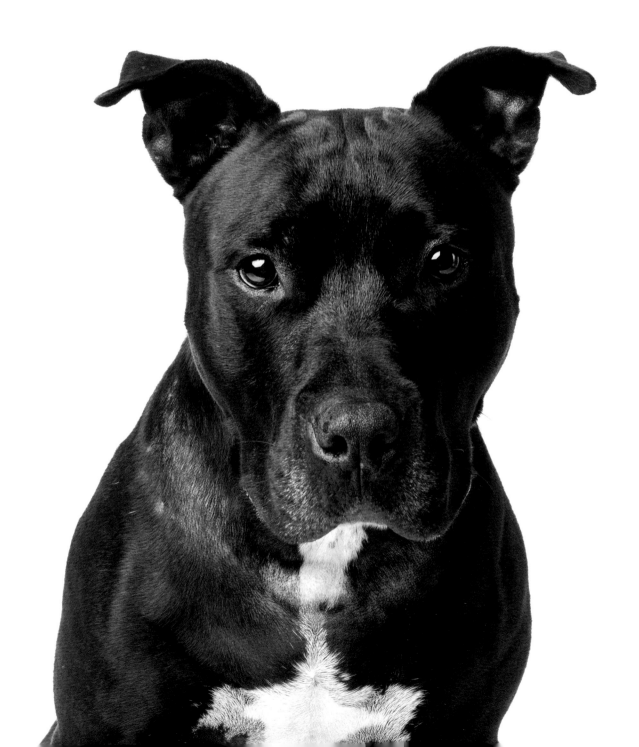

Gateway AMERICAN PIT BULL / LABRADOR RETRIEVER

Can wiggle all ninety pounds of himself onto your lap

Saint Loup BORDER COLLIE / LABRADOR RETRIEVER

Herds cats and kids

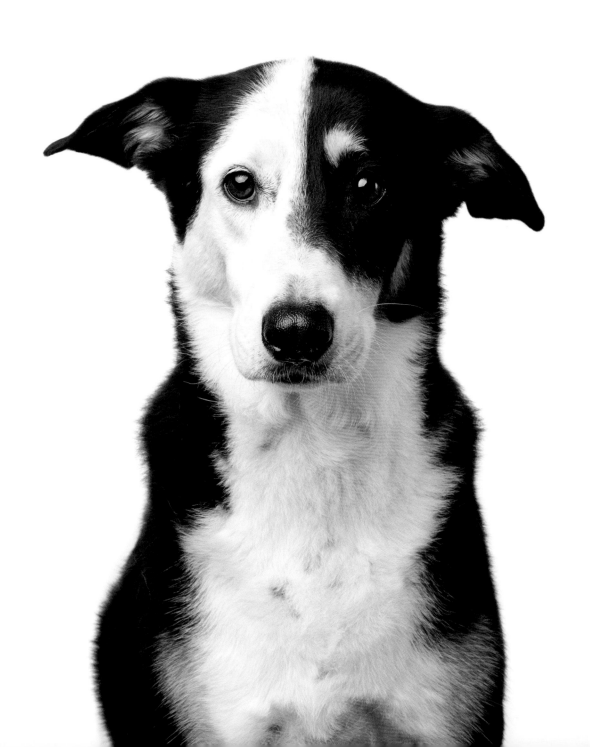

Couyon ENGLISH POINTER / LABRADOR RETRIEVER / GREAT DANE

Hates squirrels, loves balloons

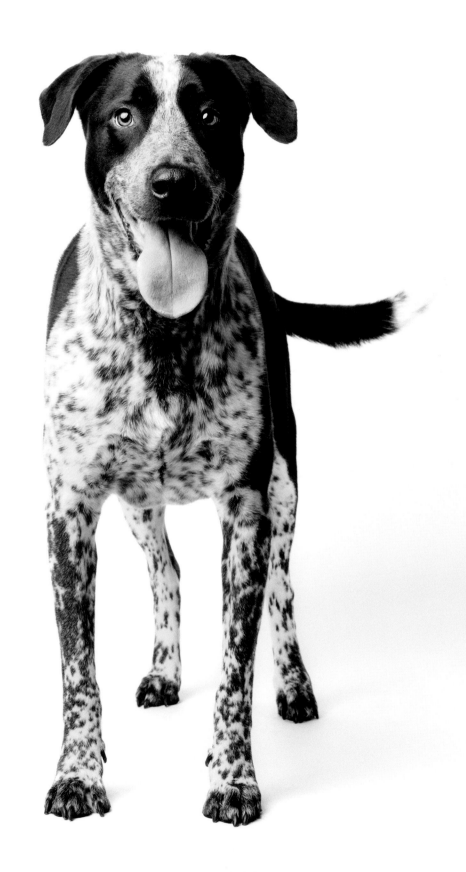

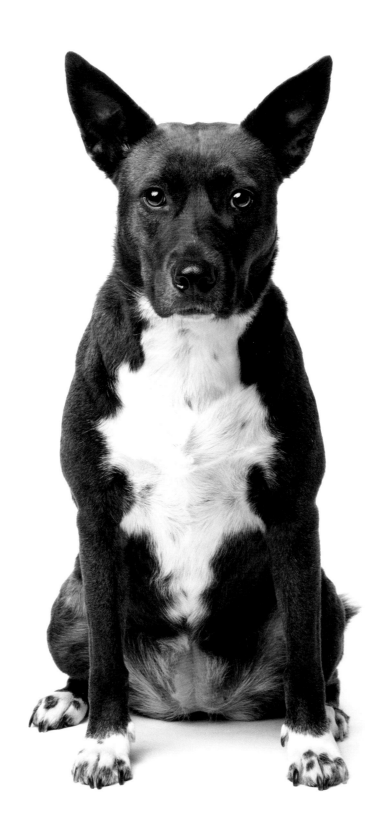

Maple LABRADOR RETRIEVER / AMERICAN BULLY / SIBERIAN HUSKY
Loves downward dog

Bebe AUSTRALIAN SHEPHERD / DACHSHUND / TERRIER
Favorite thing to eat is flip flops

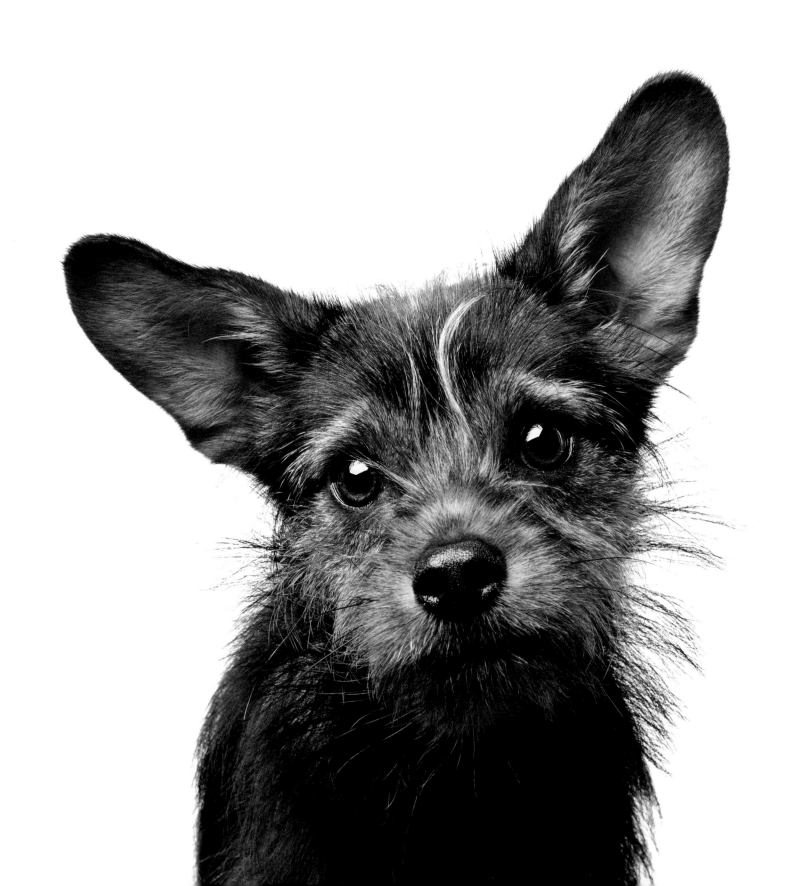

Apple Prancine AMERICAN PIT BULL / AUSTRALIAN CATTLE DOG

Prances like a Lippizaner horse

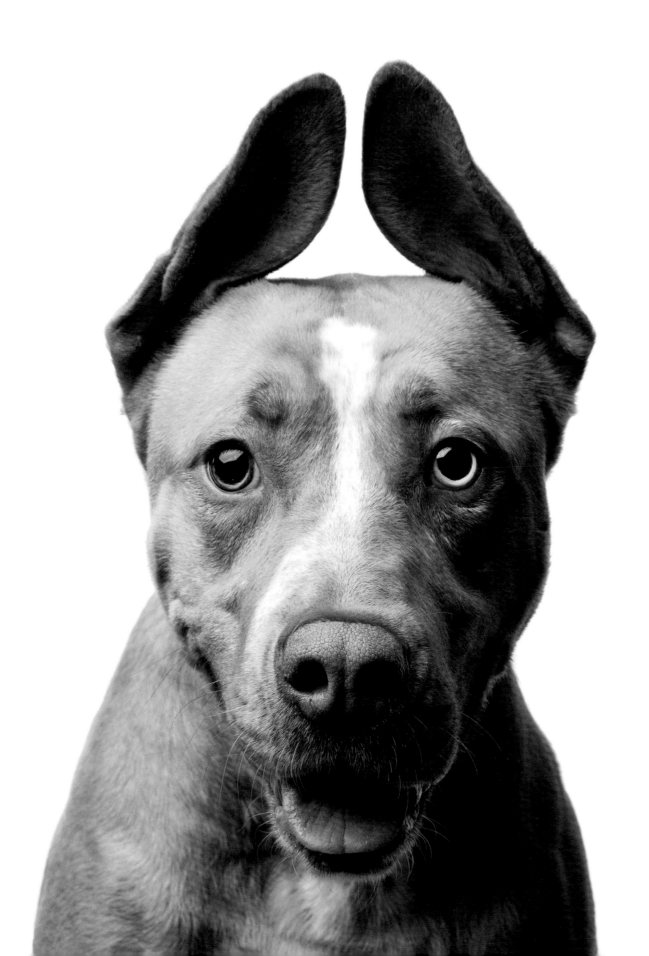

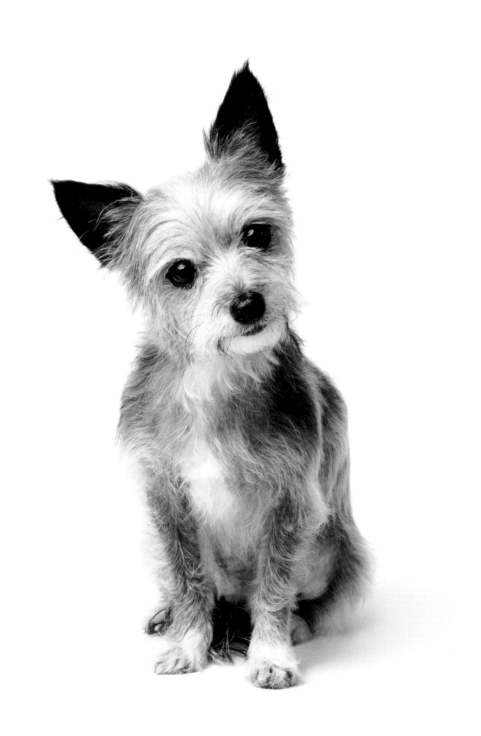

Fancy
YORKSHIRE TERRIER / MINIATURE SCHNAUZER / CHIHUAHUA

Chronic bedhead

Charlie TERRIER / AMERICAN PIT BULL / BLUE HEELER

Wags her tail so hard it shakes her whole body

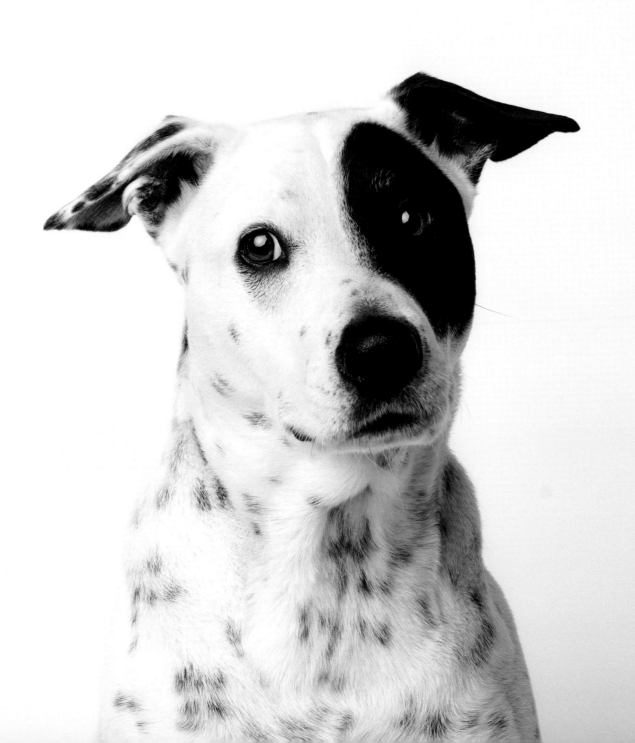

Sula SHEEPDOG / POODLE / BLUE HEELER

Must meet and greet all living, moving things: humans, birds, cats, roaches...

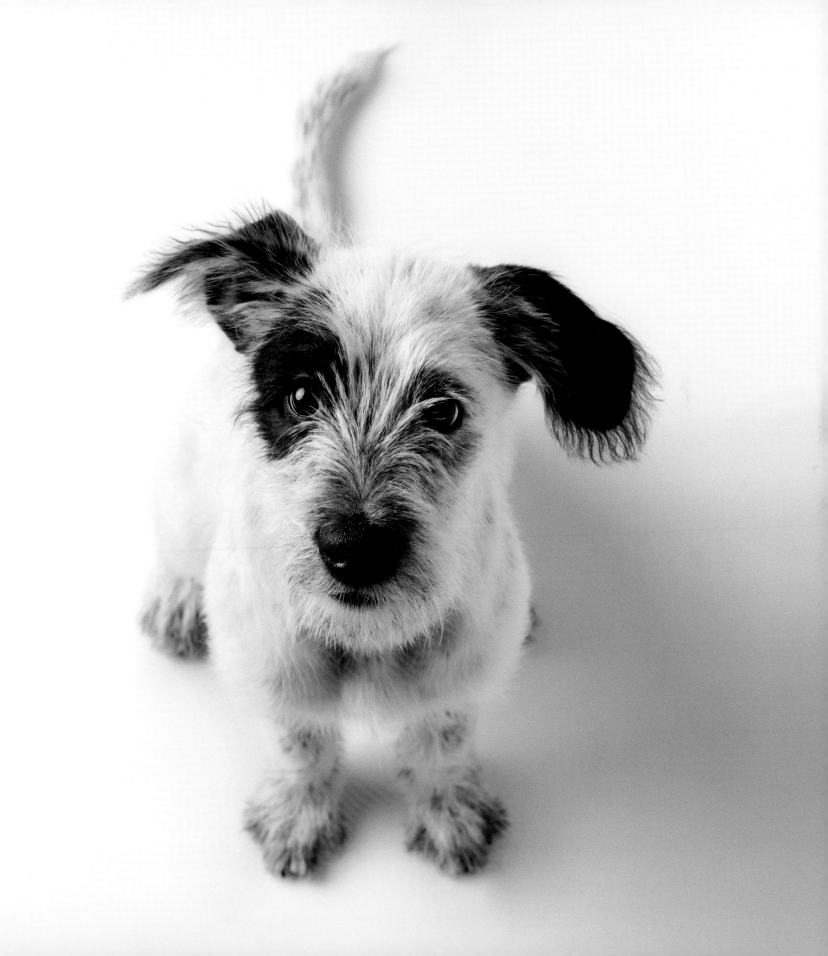

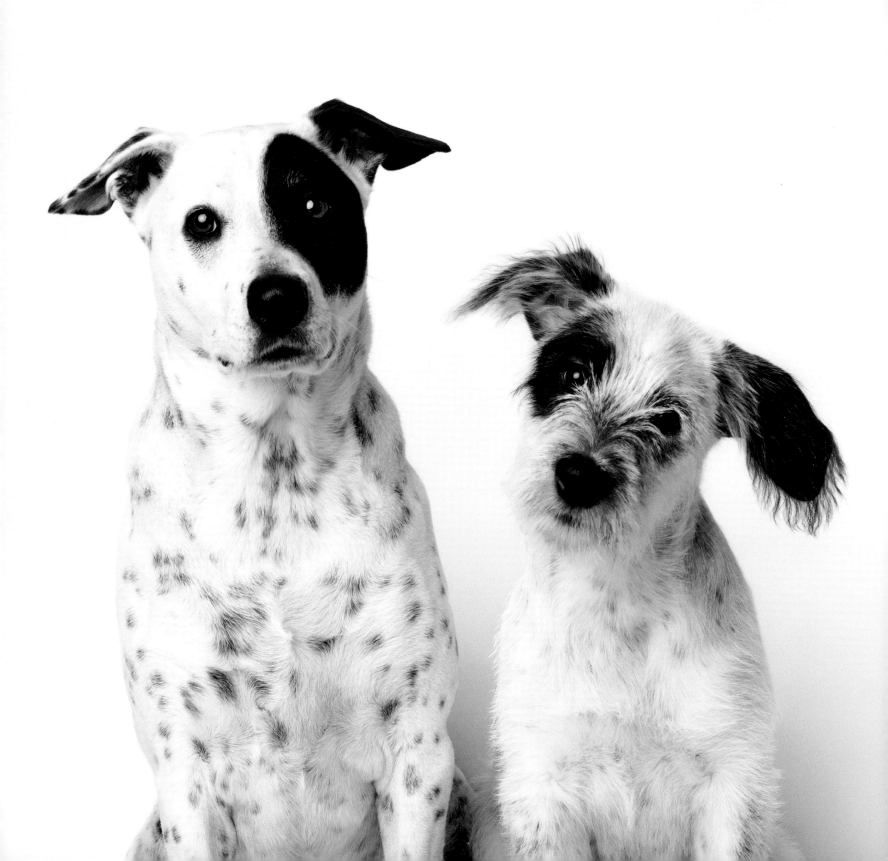

Charlie & Sula

Sisters (but not biologically!)

Cash BOXER / AMERICAN PIT BULL

Walks himself on a leash and prefers the couch cushions arranged in a certain way

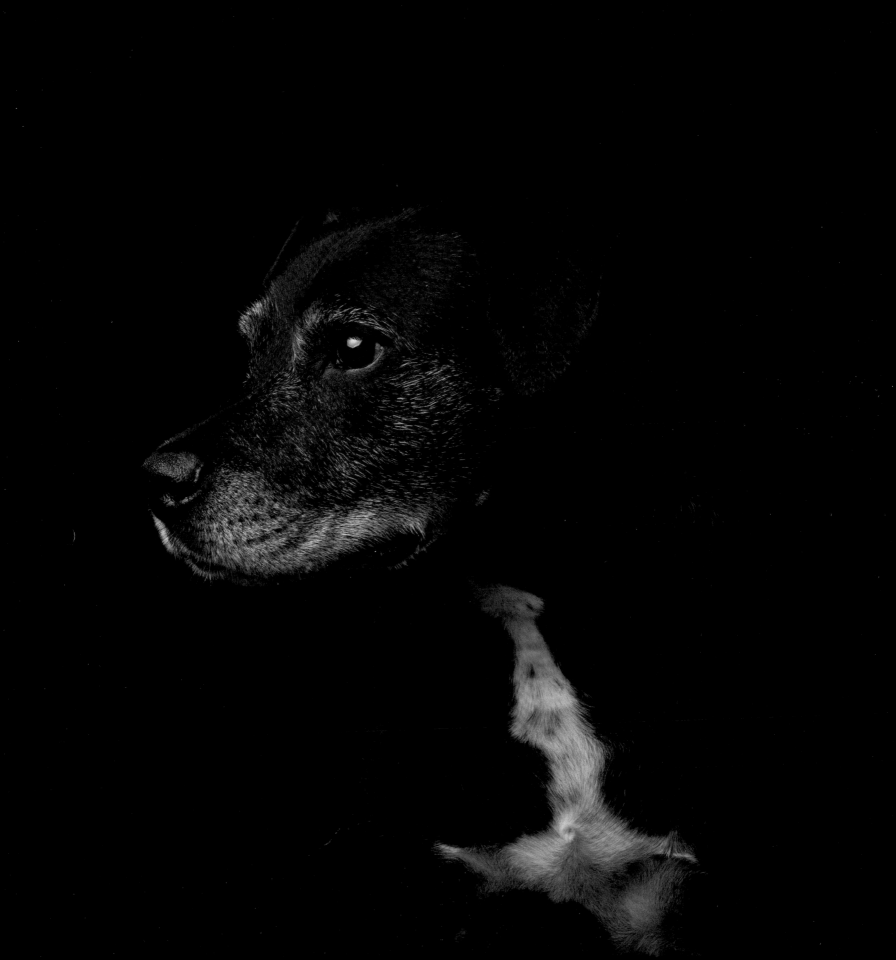

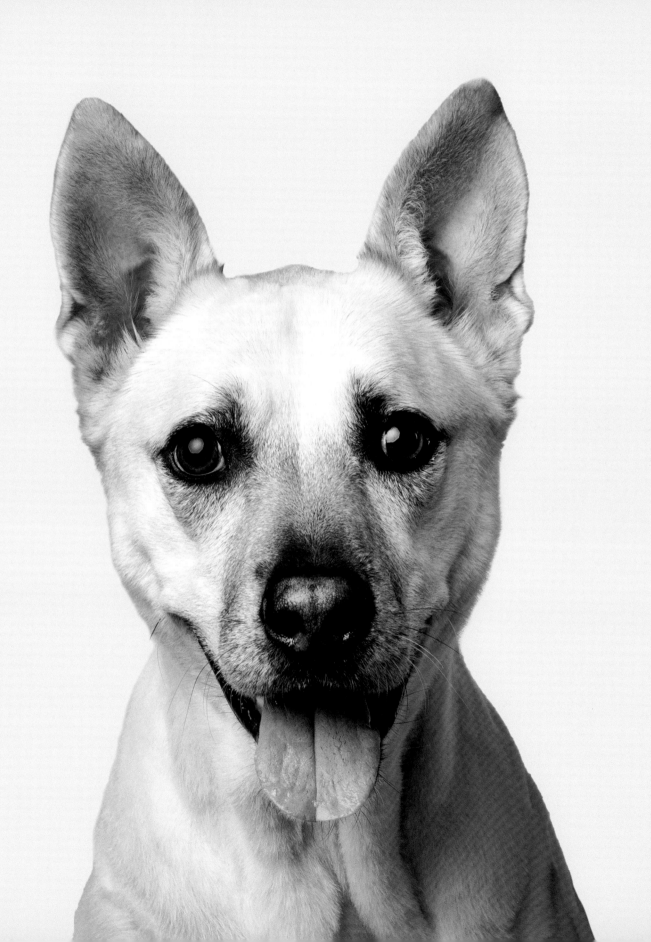

Malibu Barbie GERMAN SHEPHERD / SIBERIAN HUSKY

Never barks, just huffs, yips, and growls

Rusty SCHNAUZER / CHIHUAHUA

Bites faces, but only faces

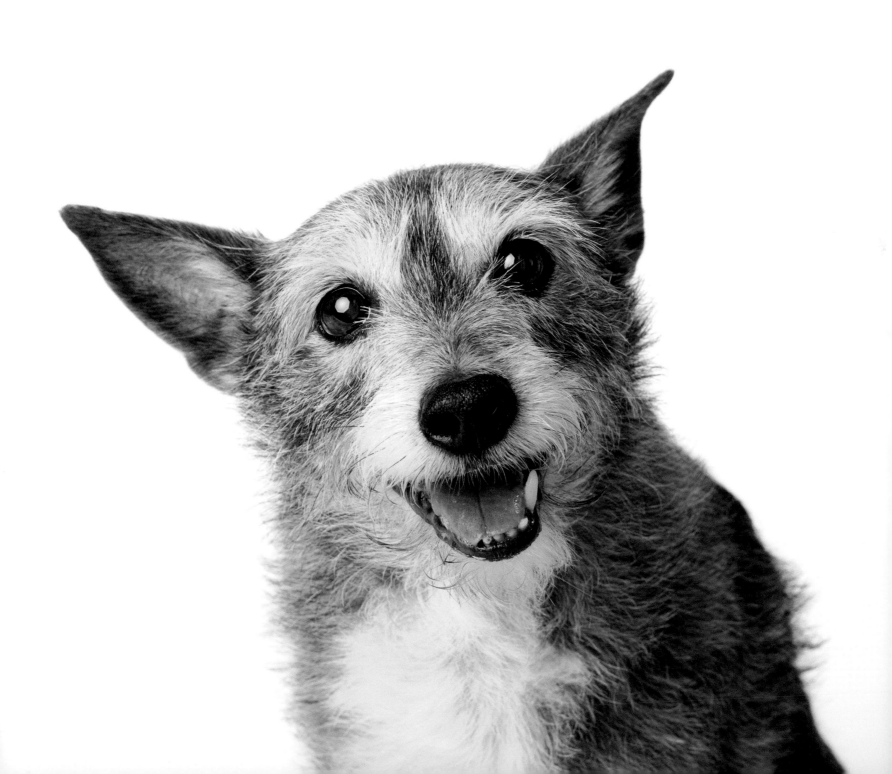

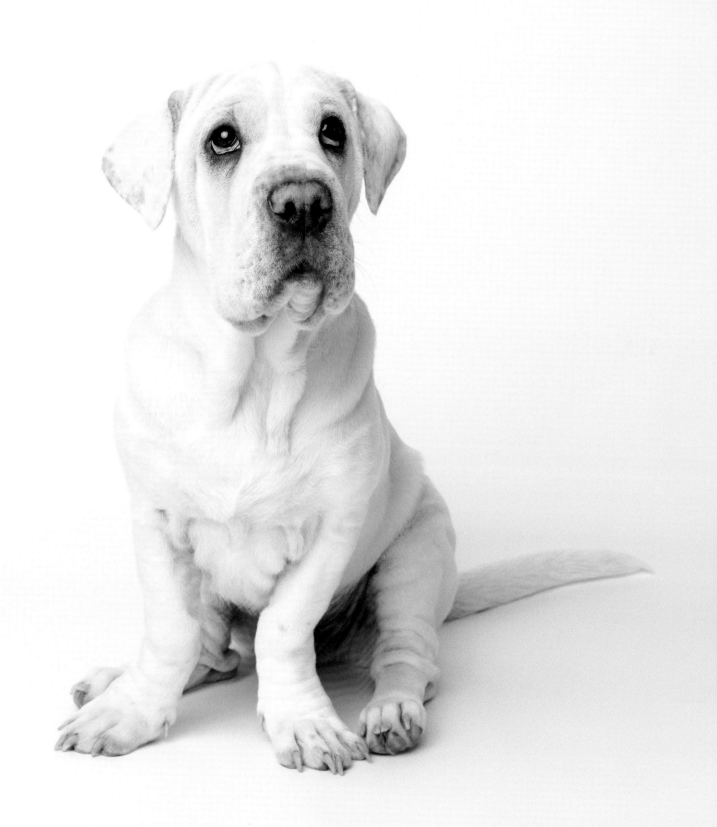

Archie SHAR PEI / BASSET HOUND

Sits down in the middle of walks to wait for passersby to pet him

Butters AMERICAN PIT BULL / GREYHOUND

Play growls when she's happy to see you

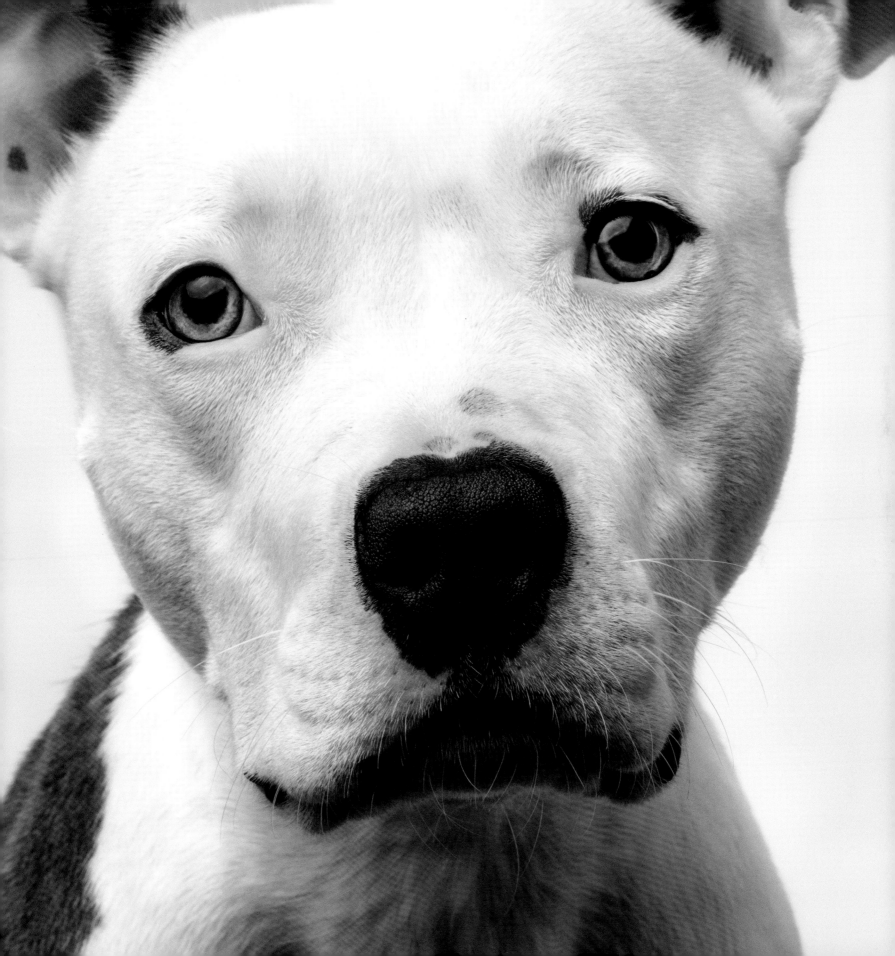

Rhea BASSET HOUND / CATAHOULA LEOPARD DOG

Loves to swim (even in winter while wearing a sweater)

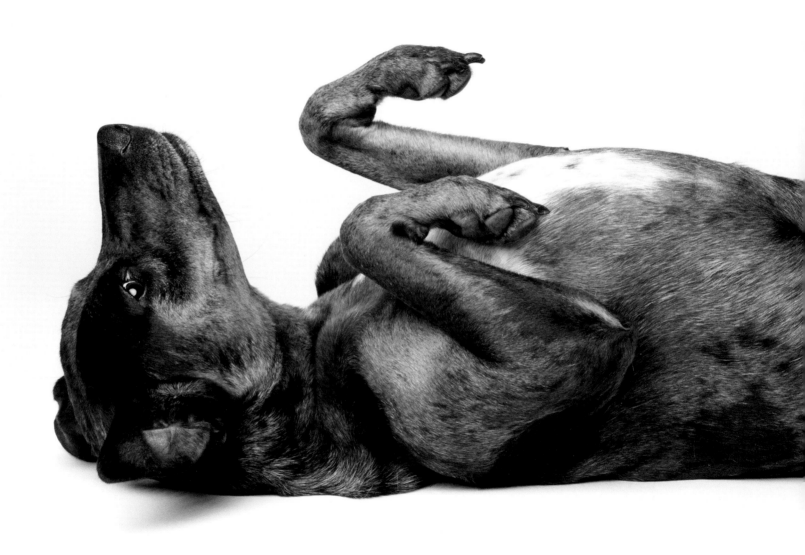

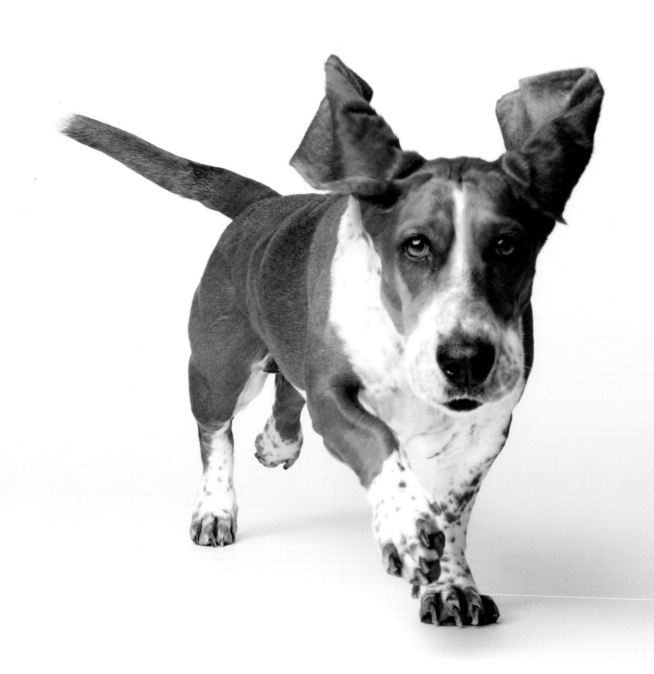

Penelope BASSET HOUND / BEAGLE
Professional napper

Cane CHOCOLATE LABRADOR / CHESAPEAKE BAY RETRIEVER

Carries a tennis ball like a pacifier everywhere he goes

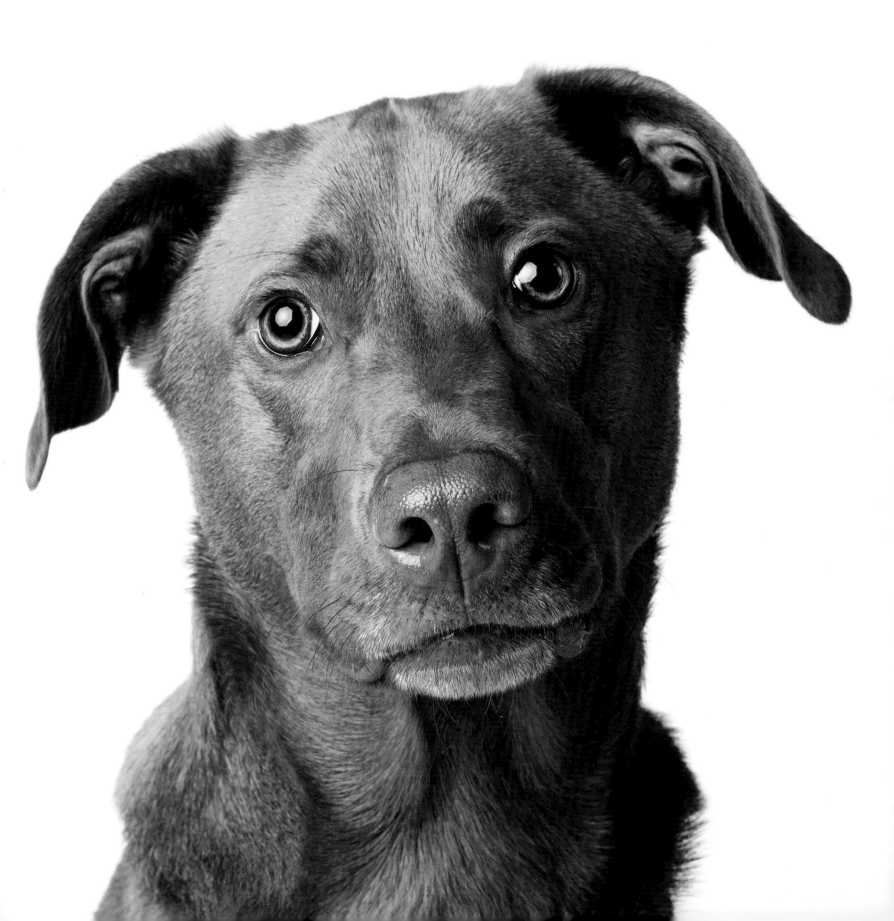

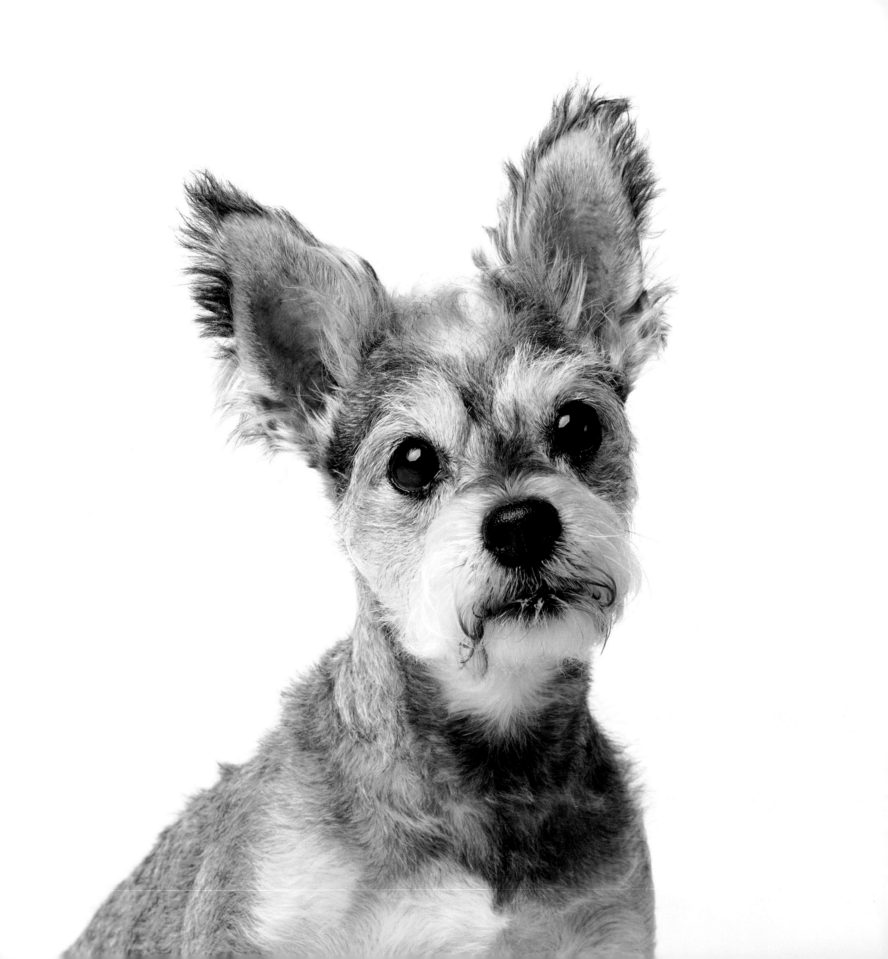

Hazel SCHNAUZER / CHIHUAHUA

Named after a rabbit from *Watership Down*

Mardi CHOW CHOW / YELLOW LABRADOR RETRIEVER

Wags his tail in circles like a helicopter

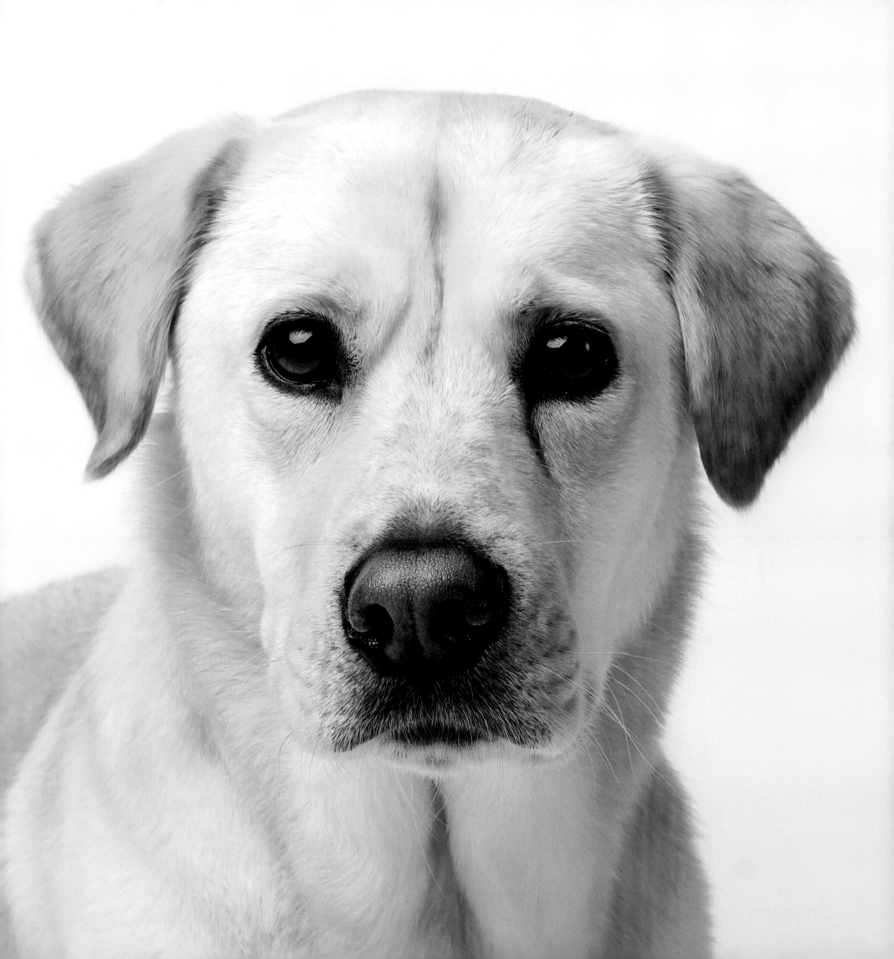

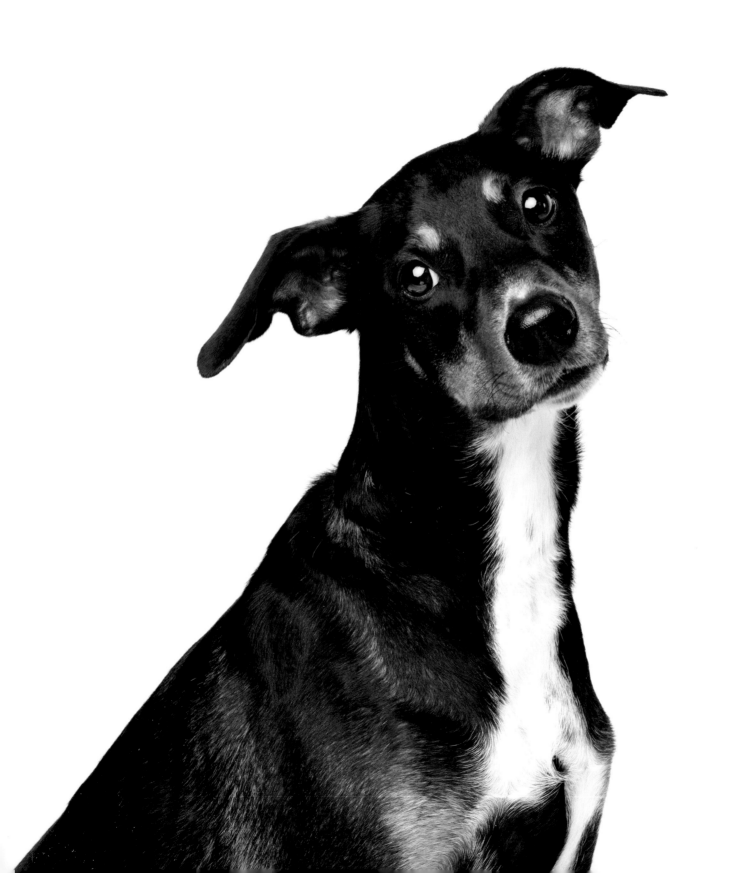

Holden DOBERMAN PINSCHER / HOUND / ROTTWEILER

Hates carbs and all green foods

Petrie BLACK LABRADOR RETRIEVER / DOBERMAN PINSCHER / BLACK GERMAN SHEPHERD

Hikes with a backpack, loves Greek yogurt

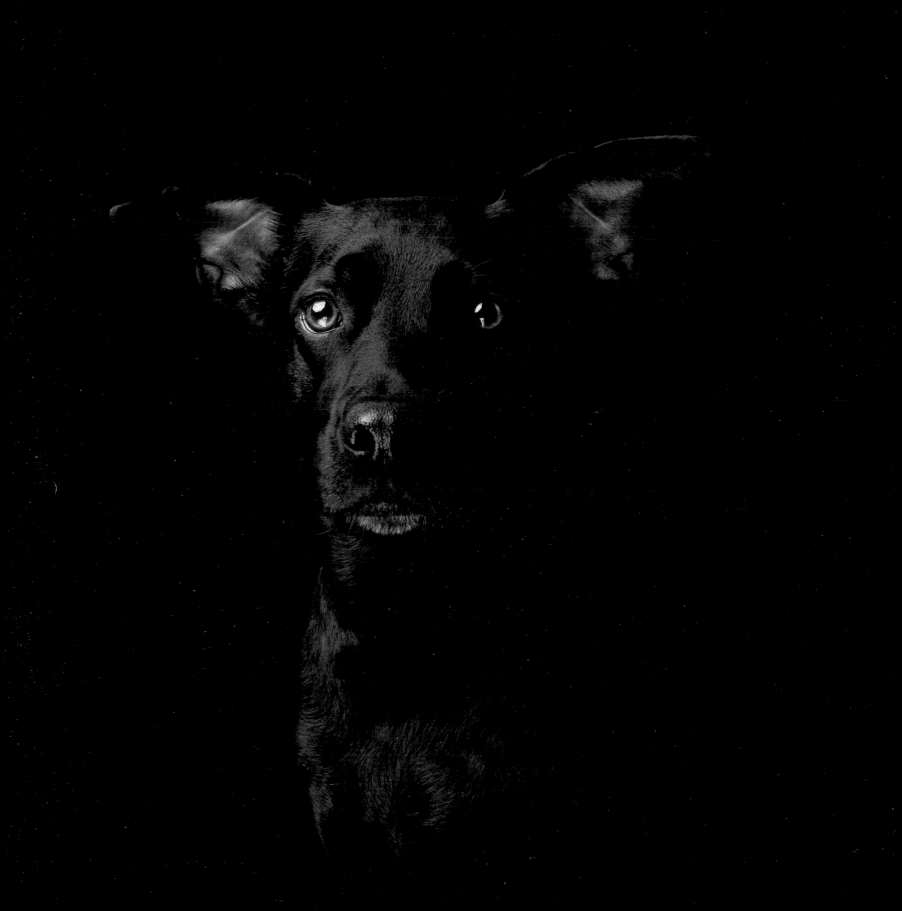

Pickle TERRIER / CHIHUAHUA

Sprints down the hallway at ninety miles an hour

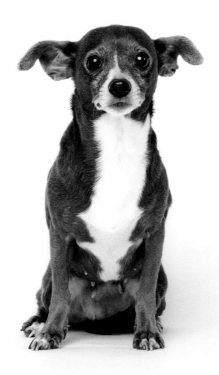

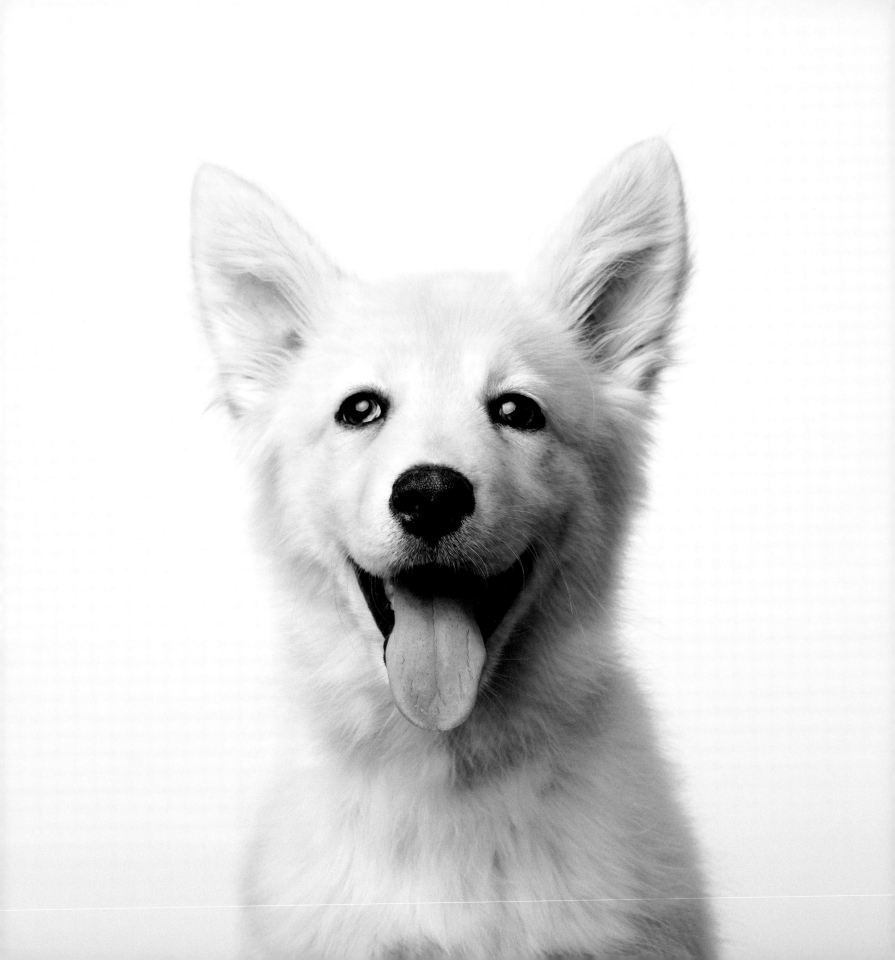

Indie SIBERIAN HUSKY / GOLDEN RETRIEVER

Naps anywhere and everywhere, howls when she's hangry

Walter BLACK MOUTH CUR / AUSTRALIAN CATTLE DOG

Looks both ways before he crosses the street, watches *Bravo TV*

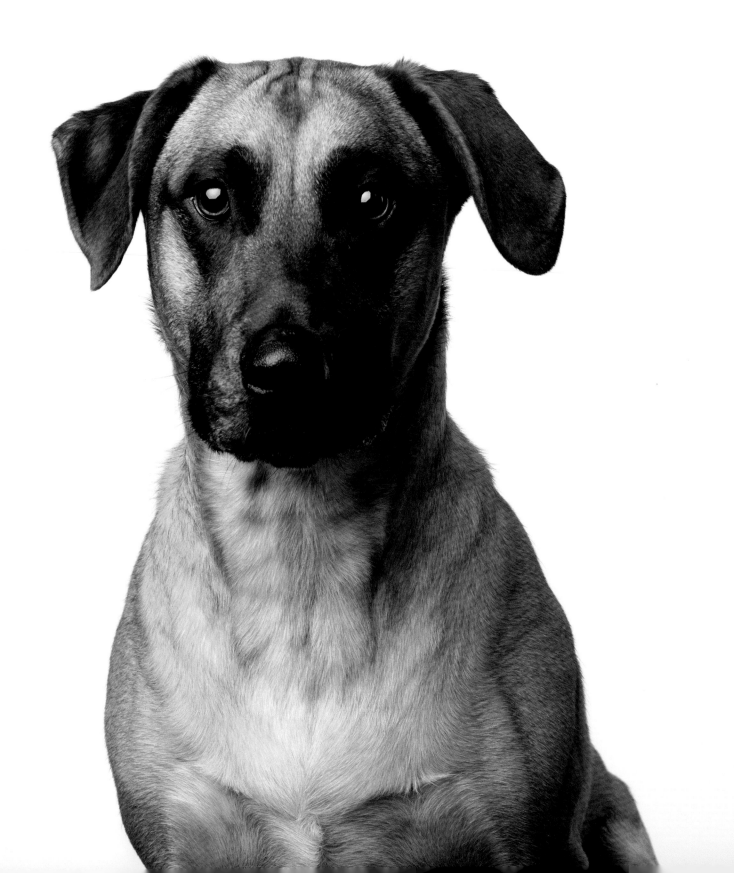

Ruby AMERICAN PIT BULL / RETRIEVER

Sneezes when she's excited and sits up like a meerkat

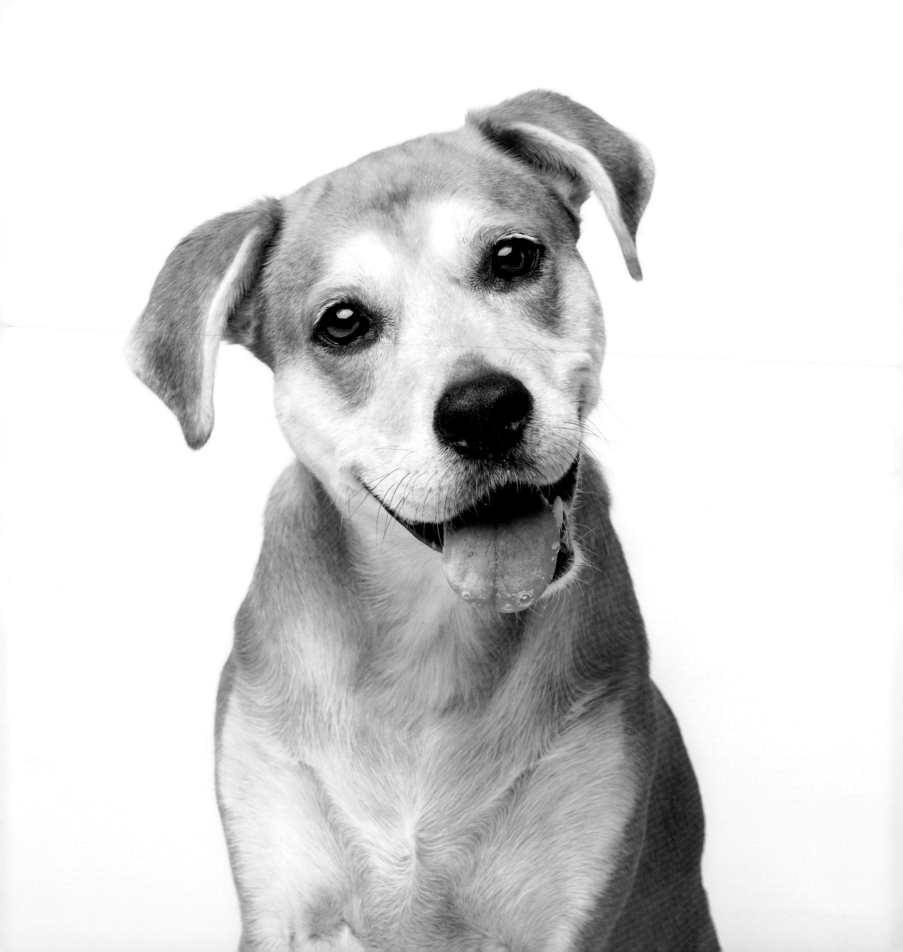

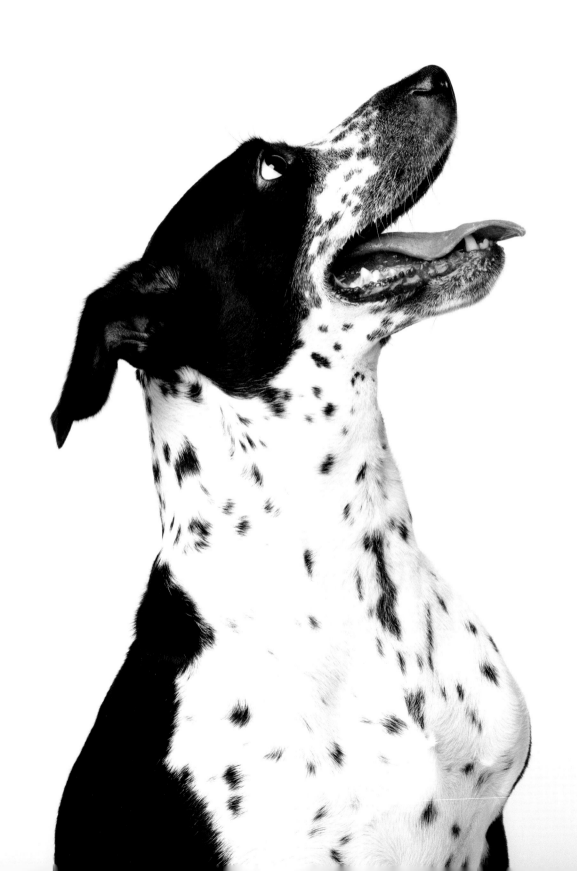

Cheyenne BORDER COLLIE / DALMATIAN

Obsessed with tennis balls

Shaggy WIREHAIRED POINTING GRIFFON / LONGHAIRED POINTER

Loves to play in the sprinkler

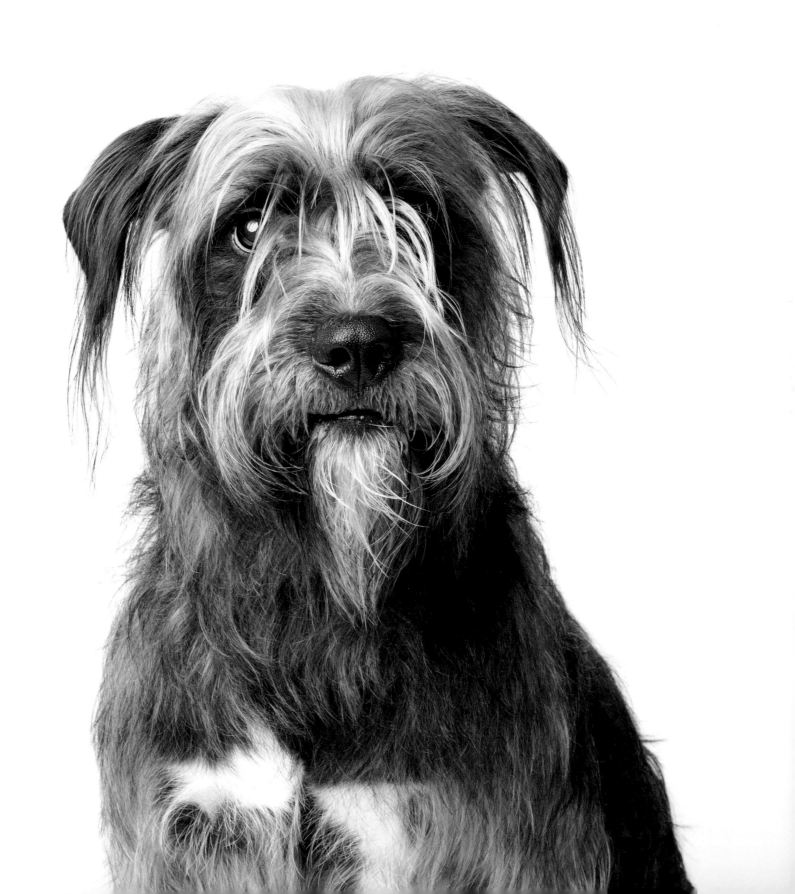

Sophie LHASA APSO / MINIATURE POODLE / TERRIER

Will only eat bougie dog food

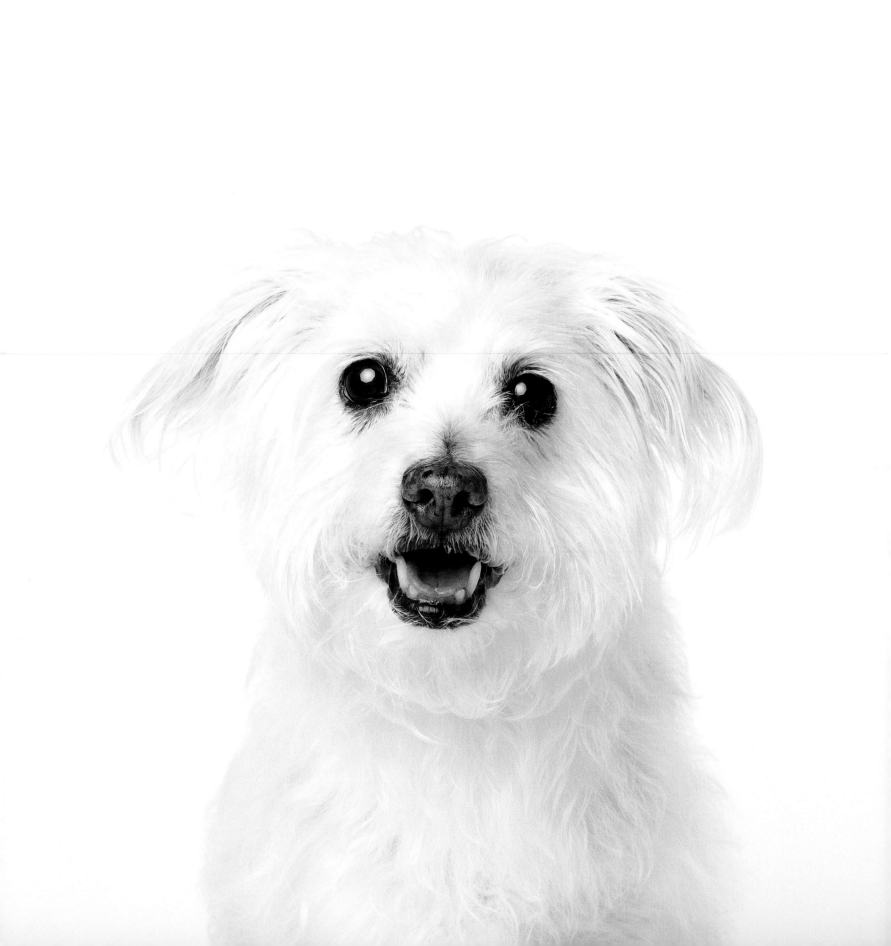

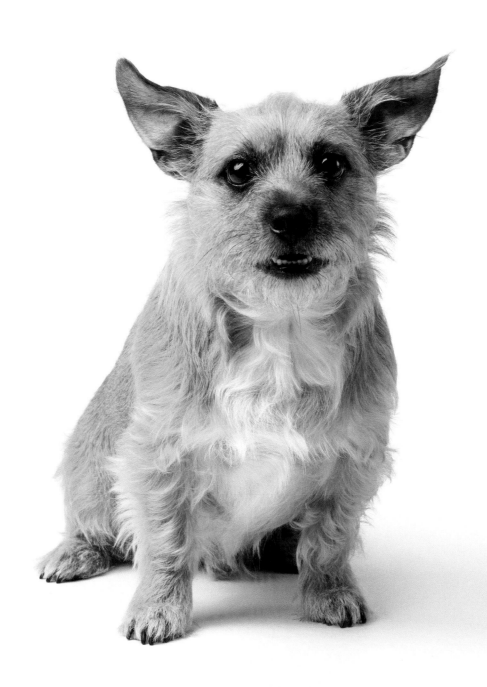

Douglas BOSTON TERRIER / BICHON FRISE / CHIHUAHUA

Has OCD ritualistic tendencies (must touch certain rugs in rooms)

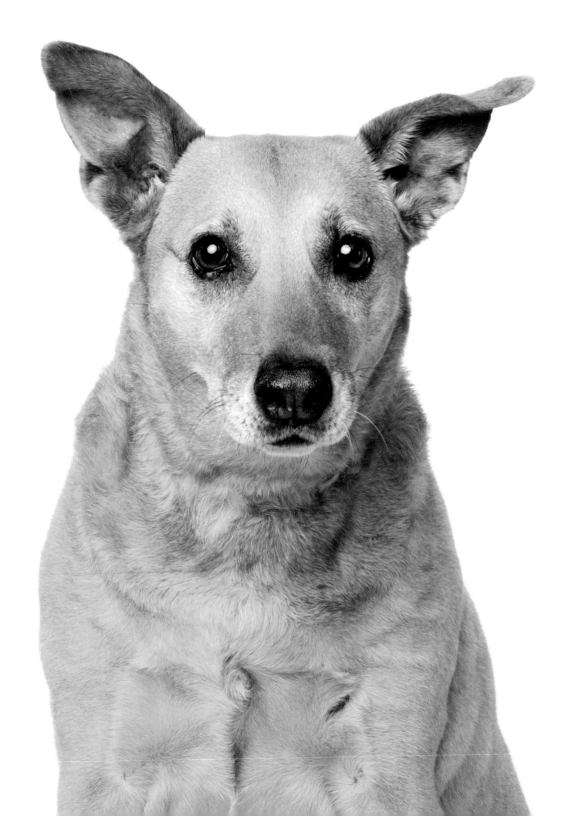

Mayday RHODESIAN RIDGEBACK / SHEPHERD / CHOW CHOW
Can salute and present arms

Rico PHARAOH HOUND / MINIATURE PINSCHER

Loves to hide bones

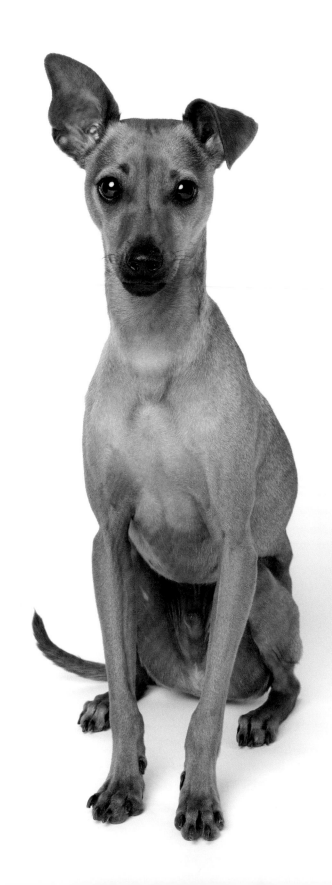

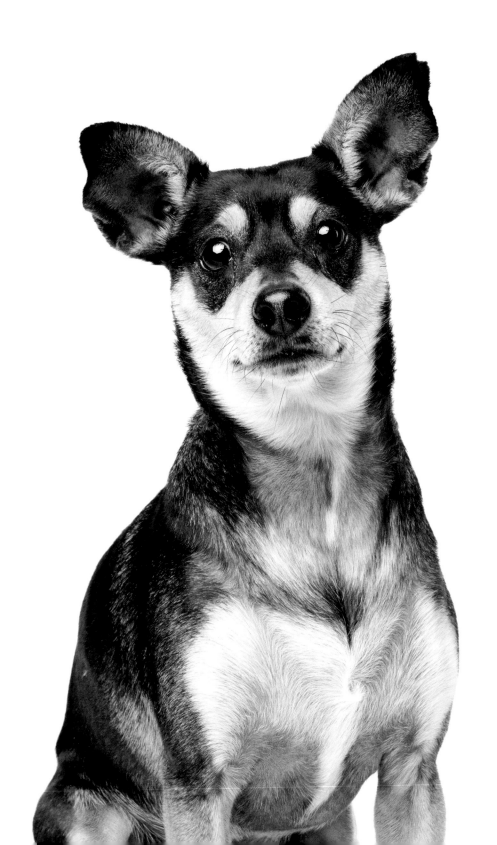

Opie MINIATURE PINSCHER / PUG / CHIHUAHUA

Total diva dog

Charlie Watts BLACK MOUTH CUR / YORKSHIRE TERRIER
Loves peppermints and candy canes

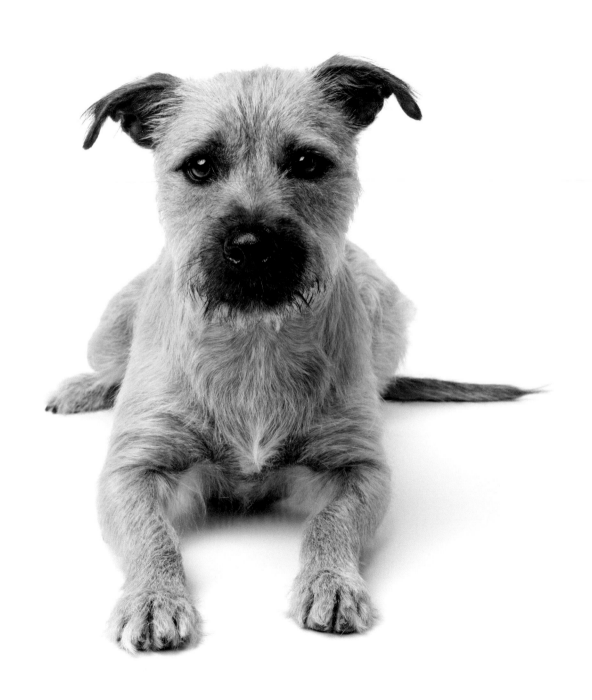

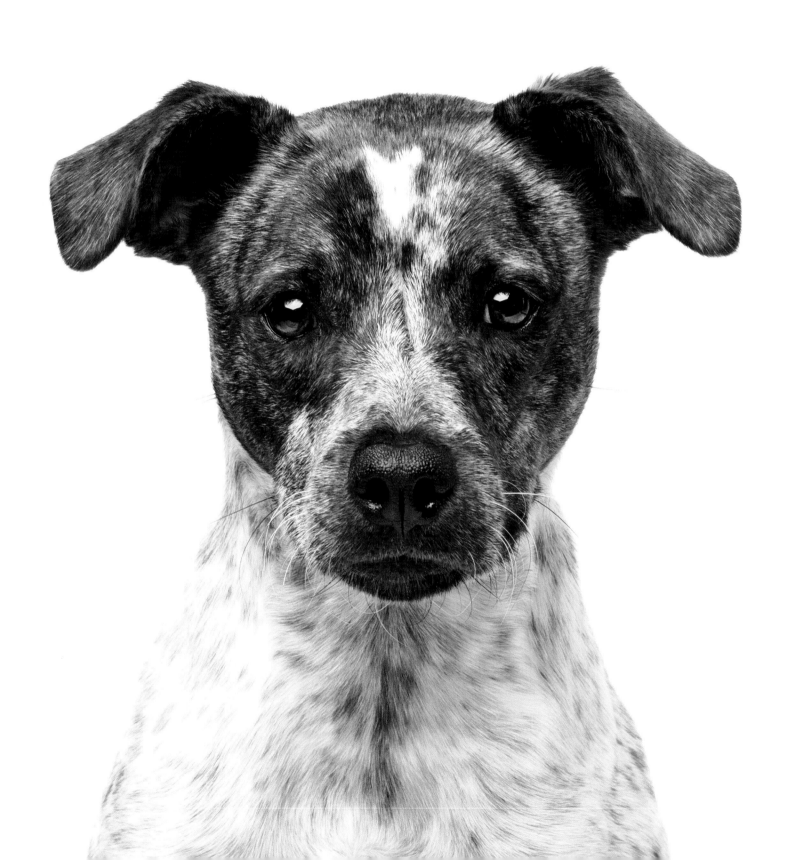

Evie RED HEELER / TERRIER / GERMAN SHORTHAIRED POINTER

Collects rocks; carries them home gently in her mouth

Lucille MALTESE / MINIATURE SCHNAUZER / BEAGLE

Opens and closes doors by herself

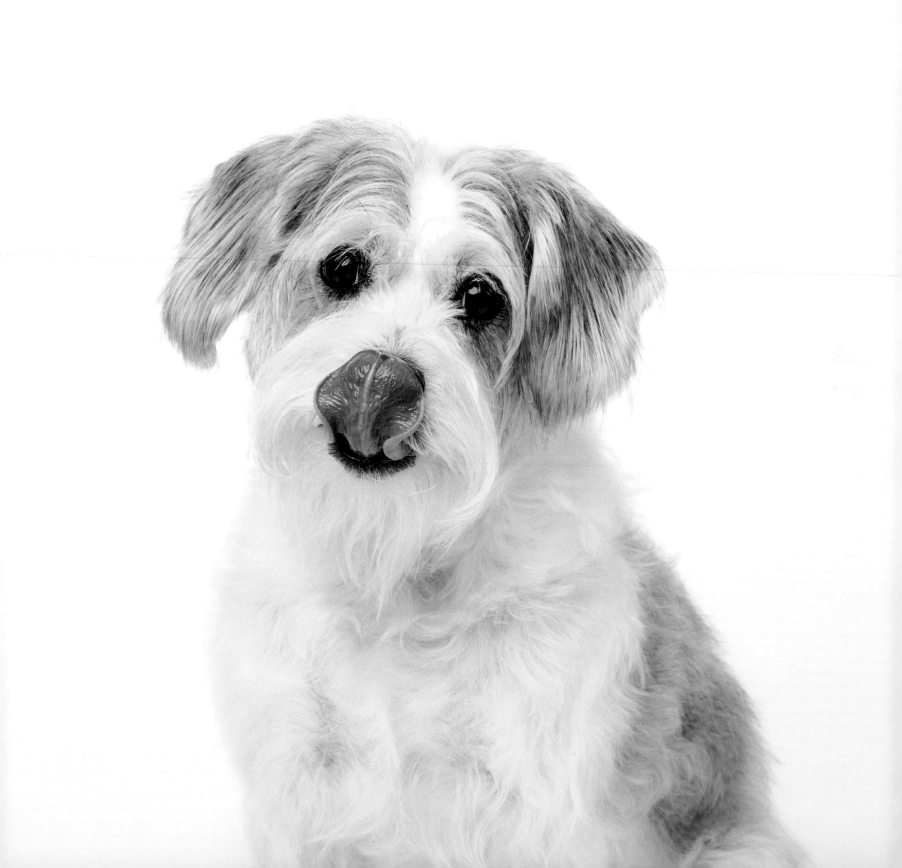

Rue PIT BULL TERRIER / AMERICAN BULLDOG
Marigold PIT BULL TERRIER / LABRADOR RETRIEVER
Otter PIT BULL TERRIER / BOXER / SHAR PEI

Love to sleep on top of each other in a pittie pile

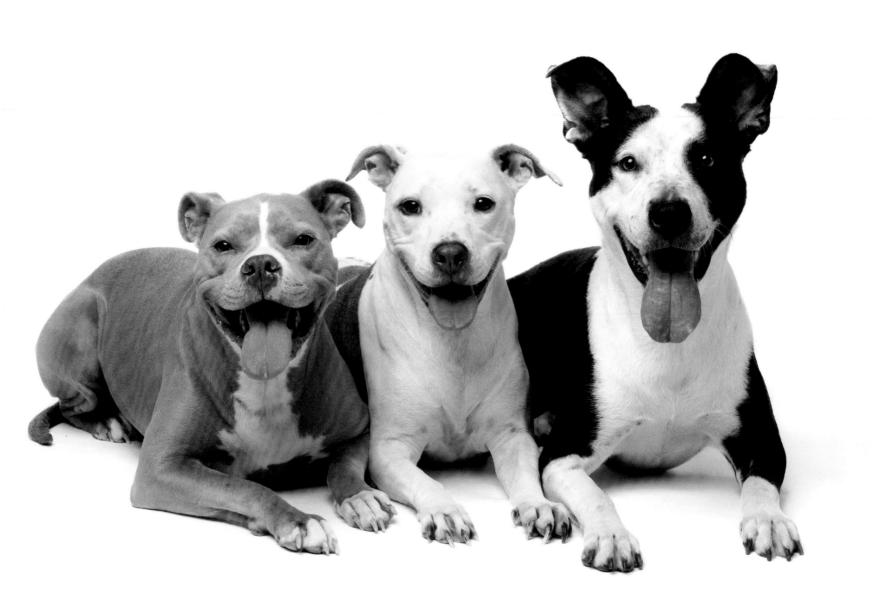

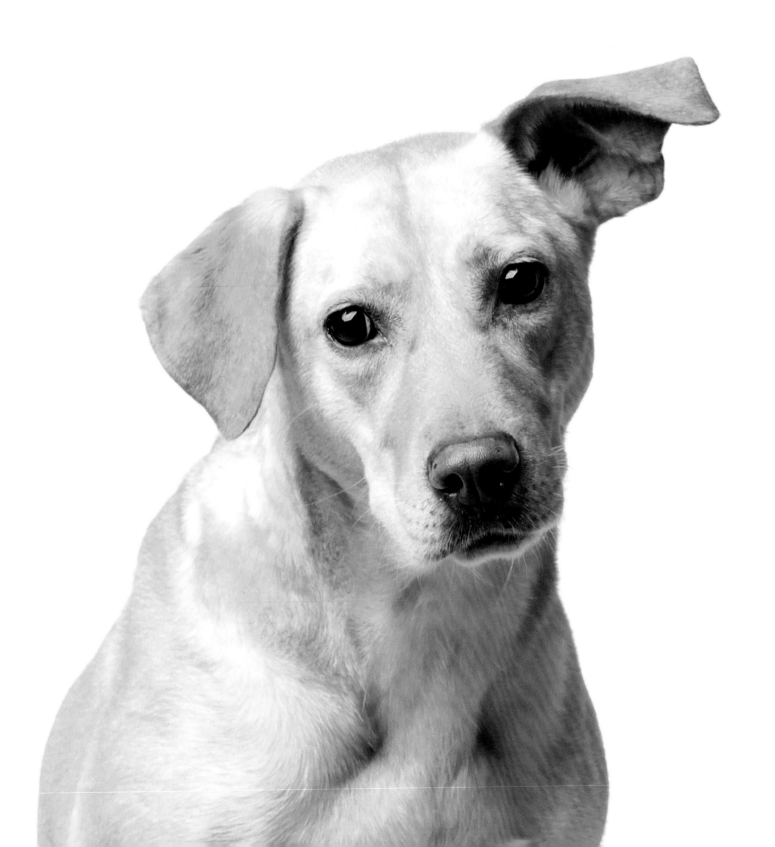

Tucson YELLOW LABRADOR / CATAHOULA LEOPARD DOG

Pounces on her unsuspecting doggy brother

Batman BLACK LABRADOR / GERMAN SHEPHERD

Lures his doggy sister into play-fighting
by pretending to lie helpless on the floor

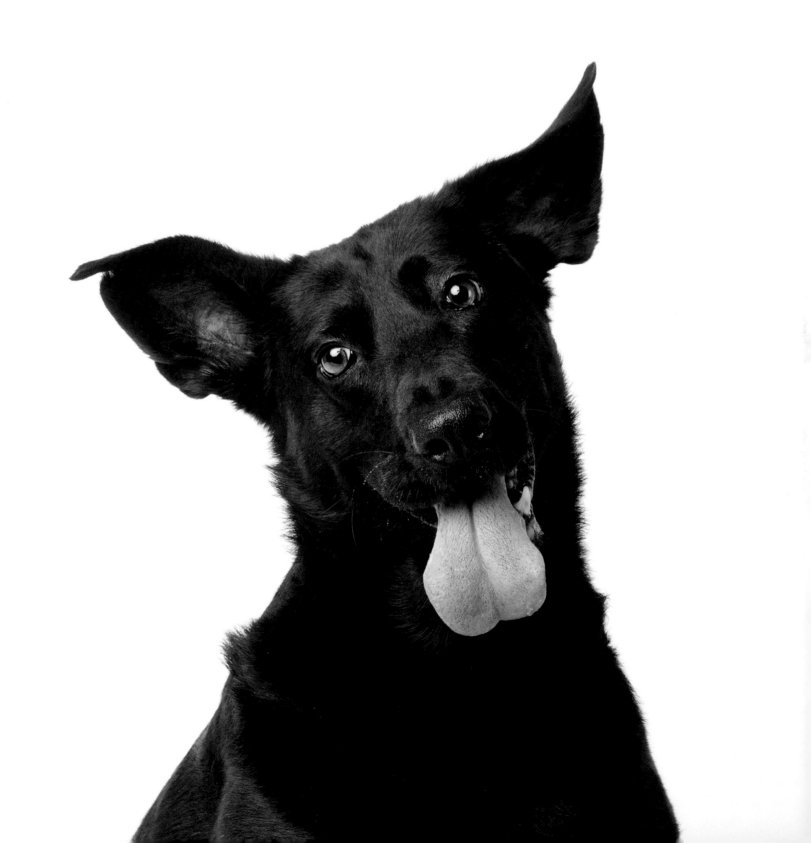

Fabio CHIHUAHUA / JACK RUSSELL TERRIER

A high-jumper who can make it onto the dining table

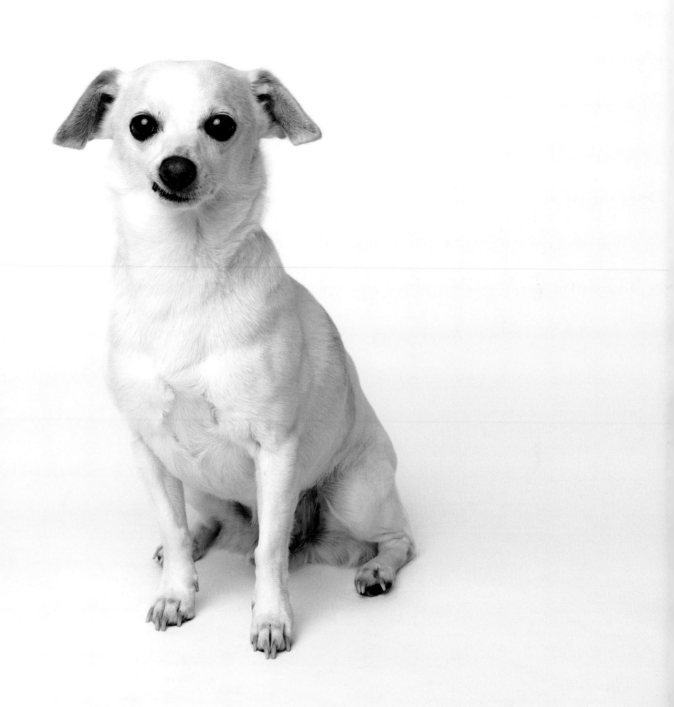

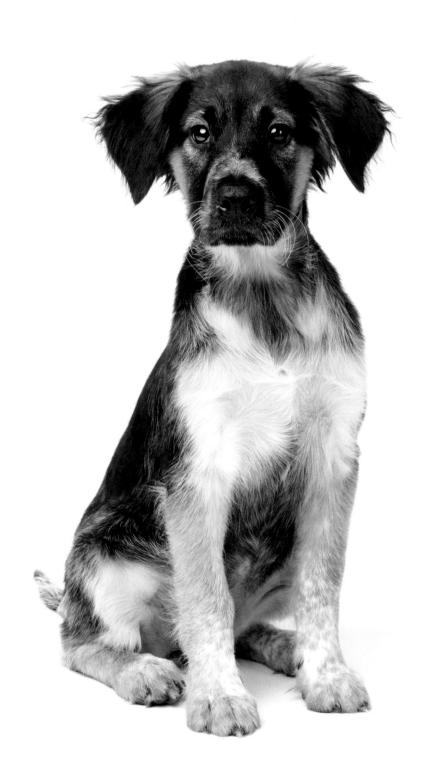

Maggie AUSTRALIAN CATTLE DOG / GOLDEN RETRIEVER / AUSTRALIAN SHEPHERD

Loves ice cubes and comes running when she hears the ice dispenser

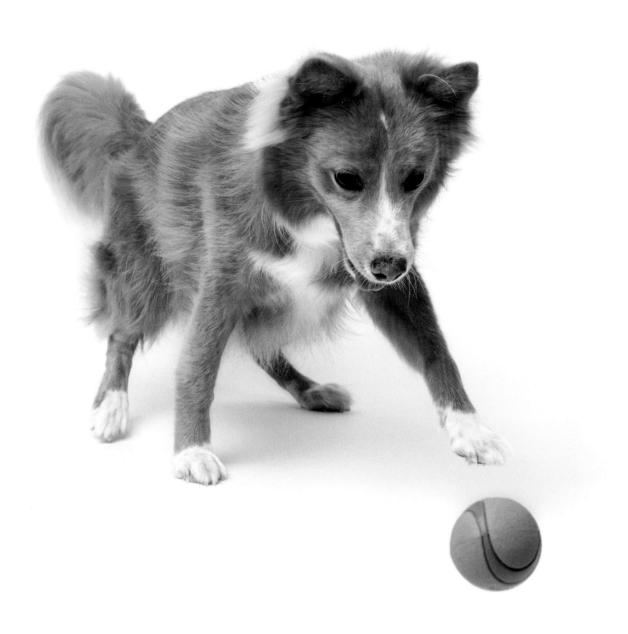

Alice NOVA SCOTIA DUCK TOLLING RETRIEVER / SHETLAND SHEEPDOG

Her ball is life

Clotile MINIATURE SCHNAUZER / SHIH TZU

Small but fierce

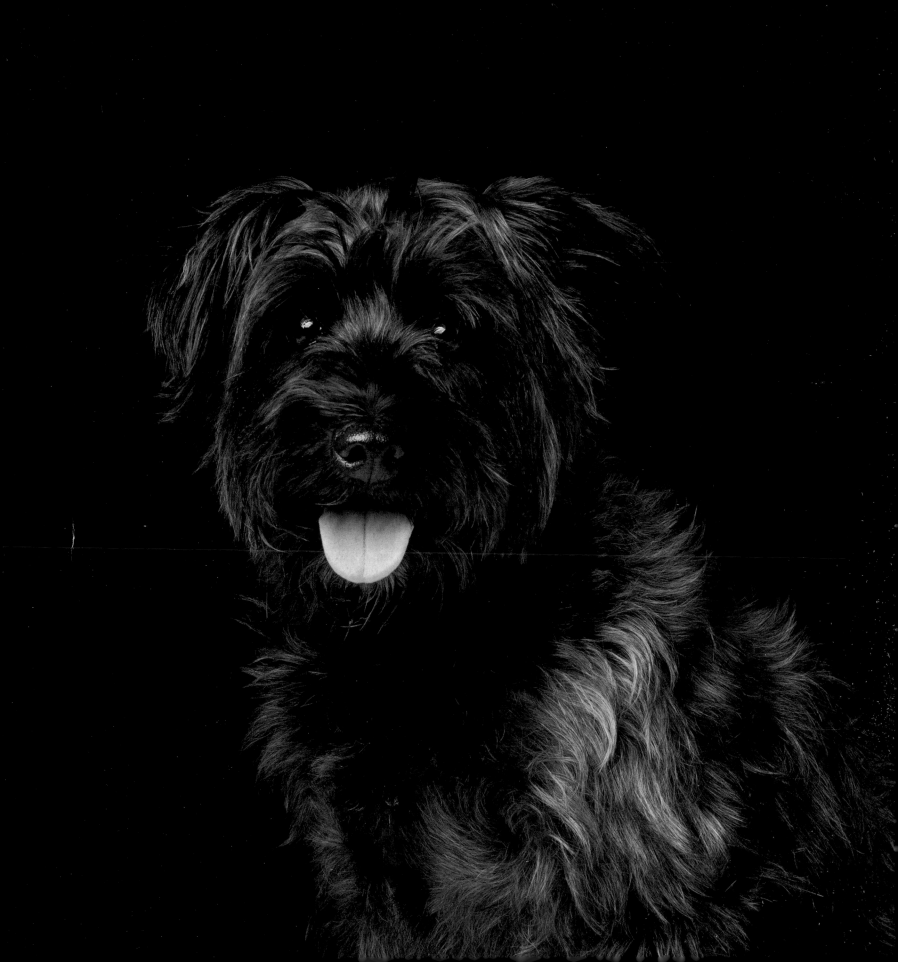

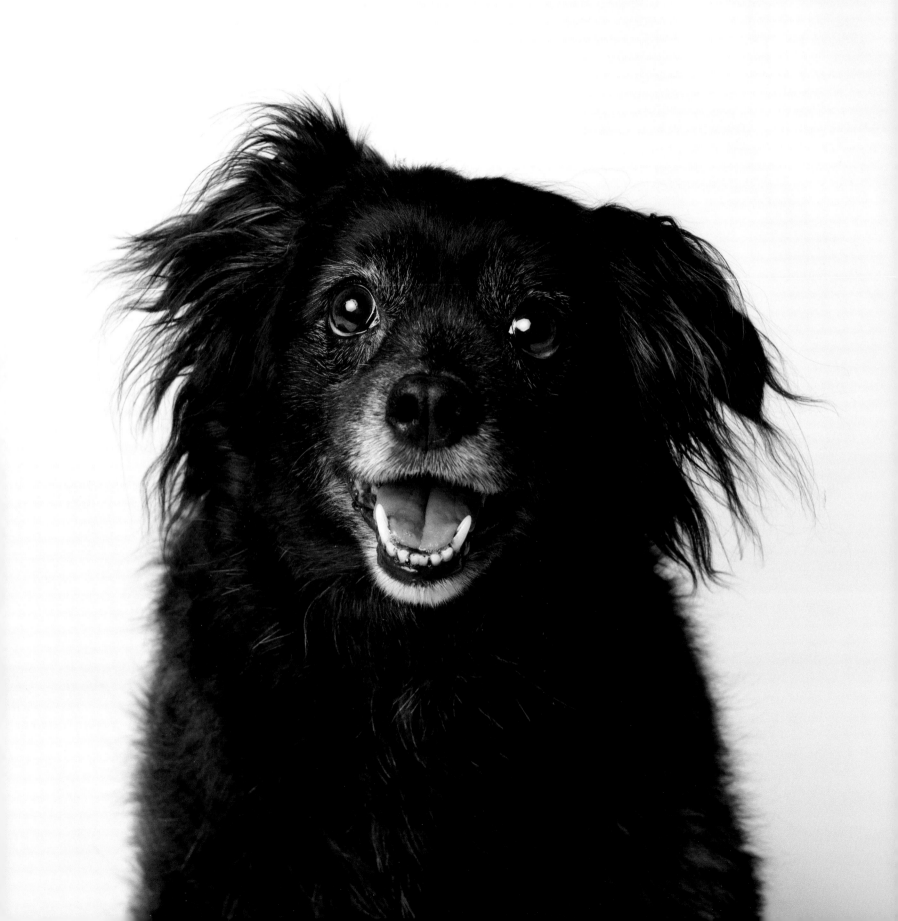

Rue POODLE / COCKER SPANIEL / SCHIPPERKE

Loves hide & seek

Finn FOXHOUND / BEAGLE / TERRIER / CHOW CHOW

Screams when he barks

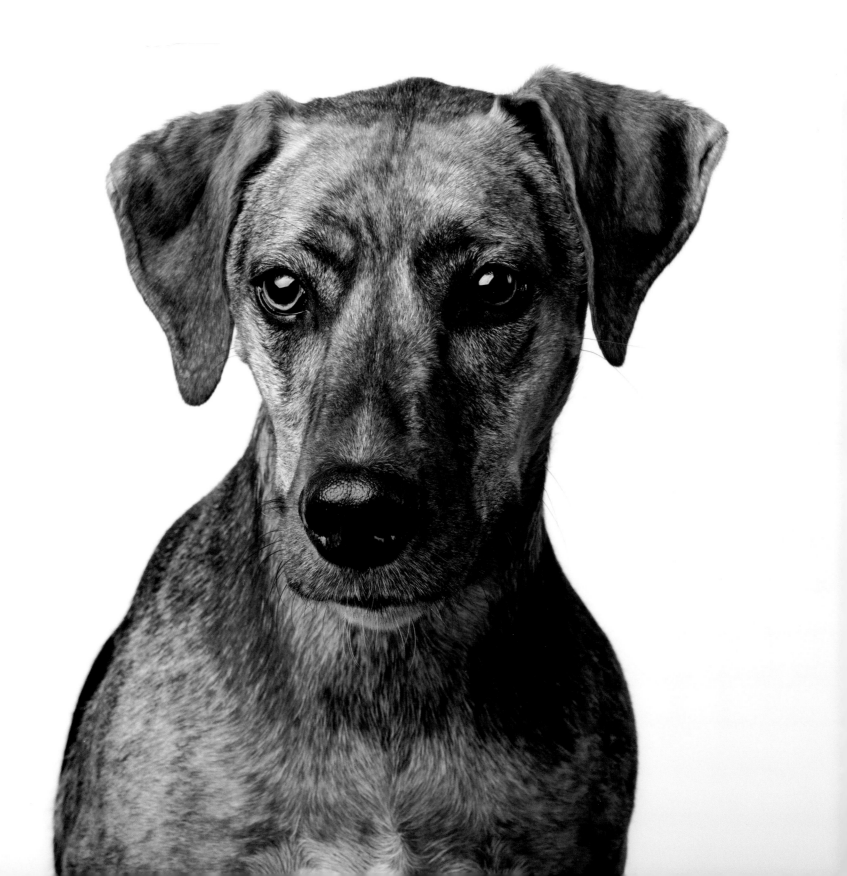

Benji TERRIER / WOLFHOUND
Most stubborn dog you'll ever meet

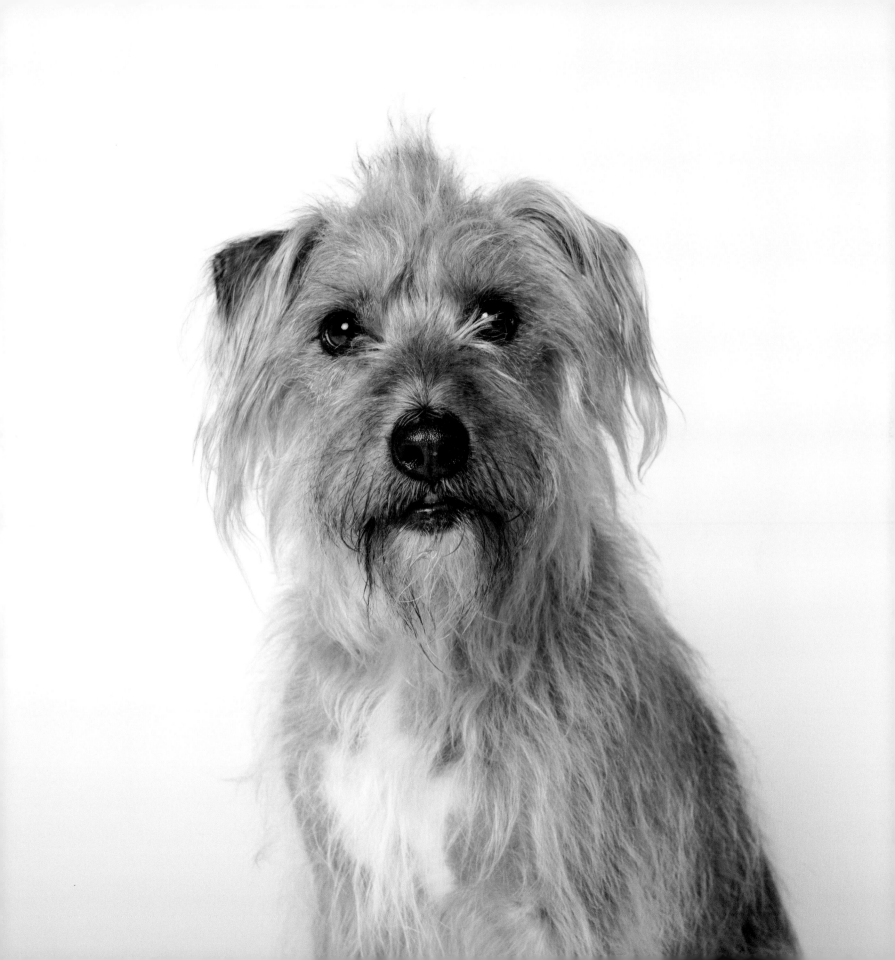

Lucky BULLDOG / SHIH TZU

He bites

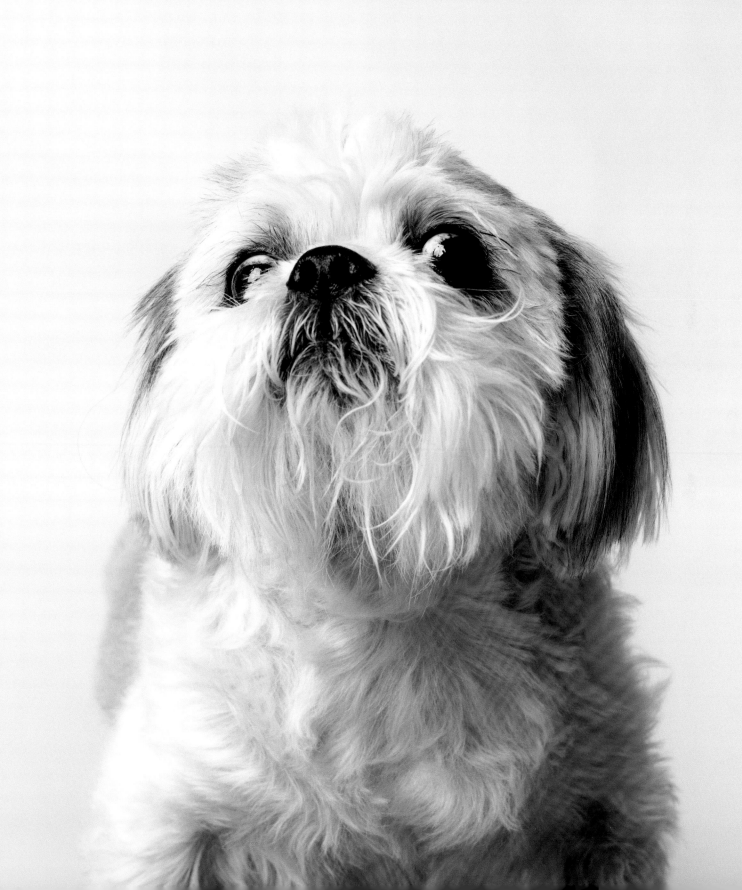

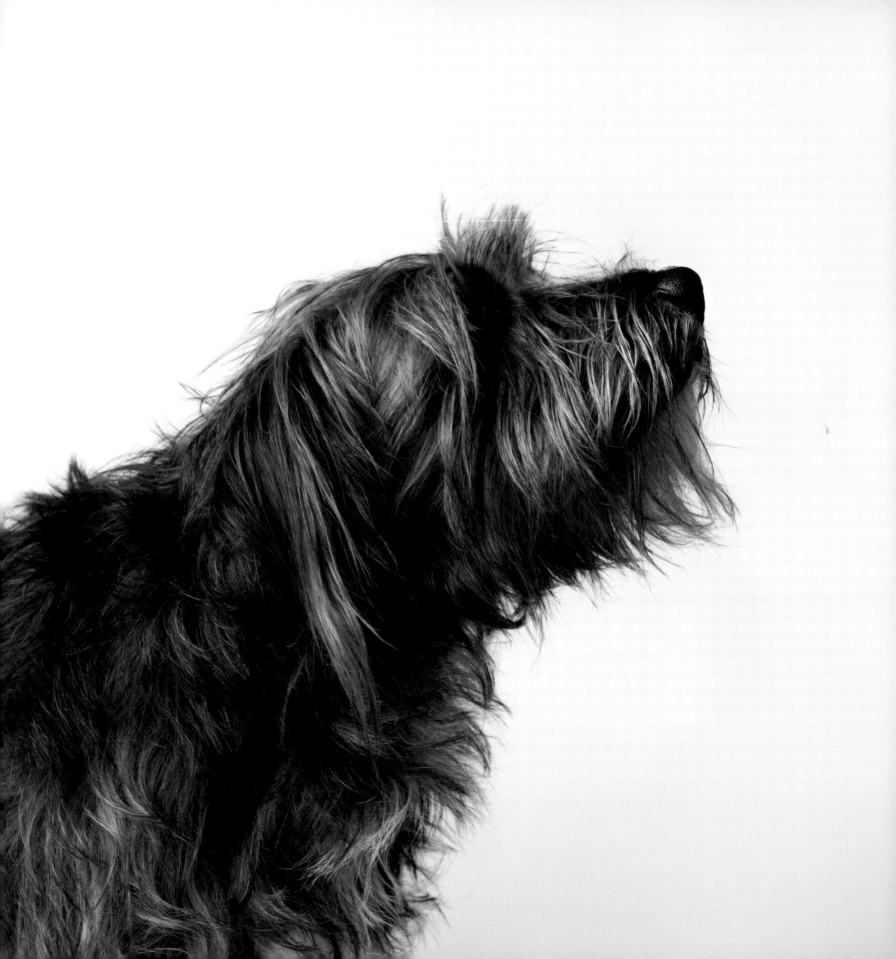

Gracie MINIATURE SCHNAUZER / PIT BULL

Howls hello to her humans

Munch BEAGLE / LABRADOR RETRIEVER

Can jump five feet high

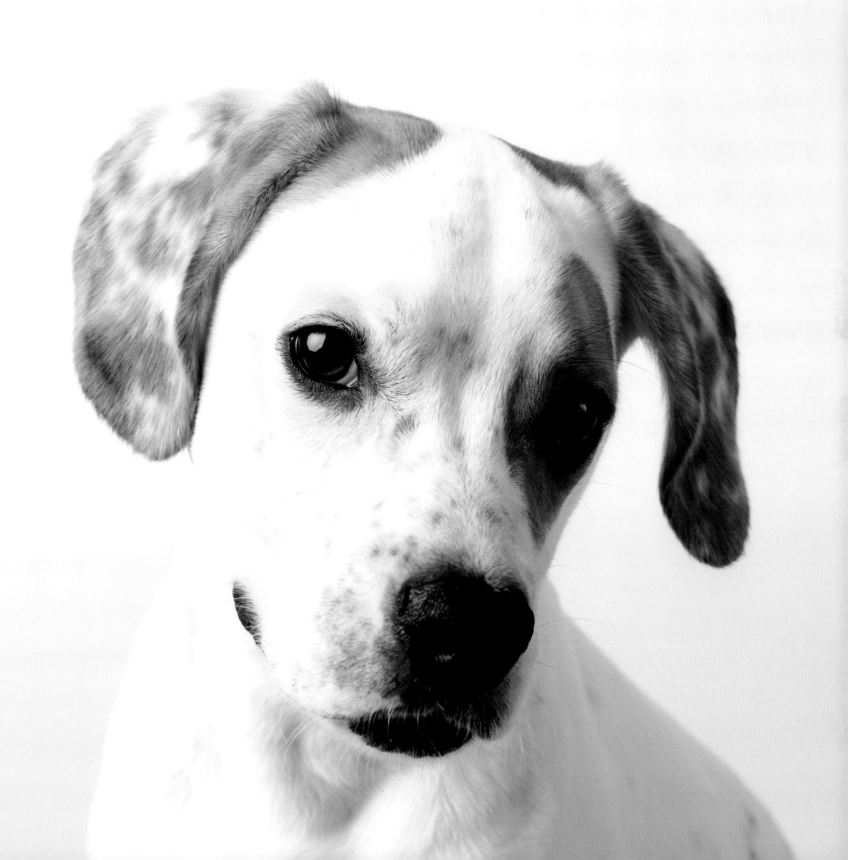

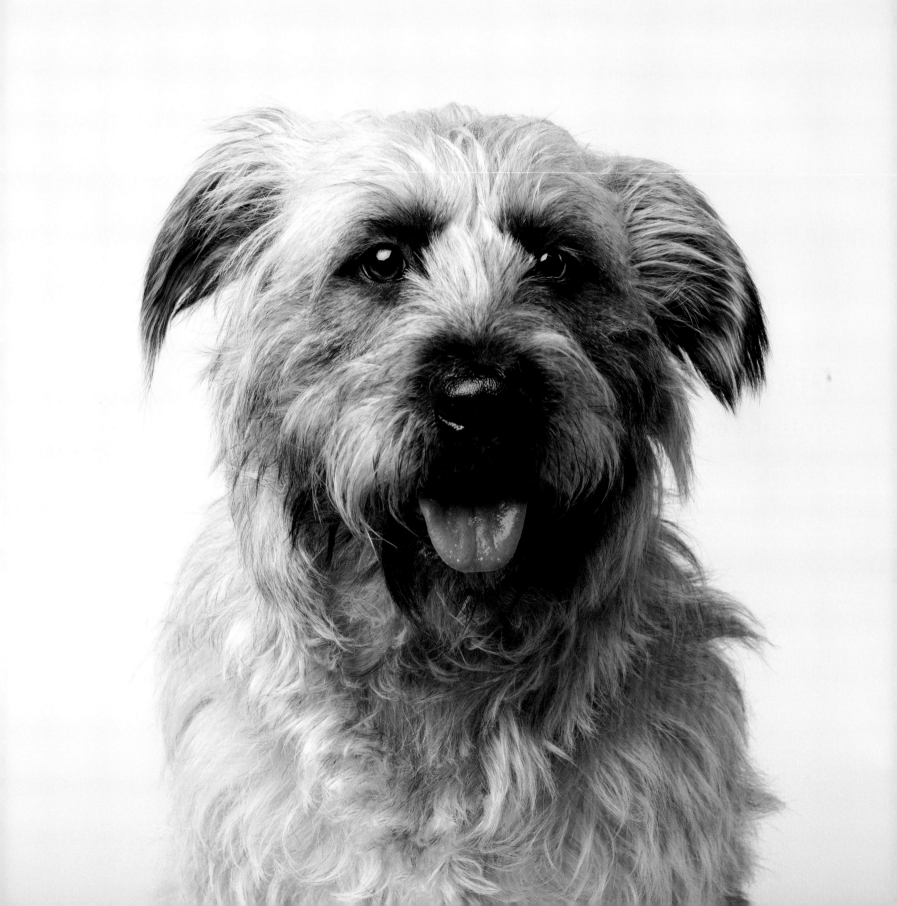

Phineous WHEATON TERRIER / STAFFORDSHIRE TERRIER

Visits the entire neighborhood for belly rubs

Murphy CHOW CHOW / PEKIGNESE / ROTTWEILER

Will only sleep on a pillow or a human

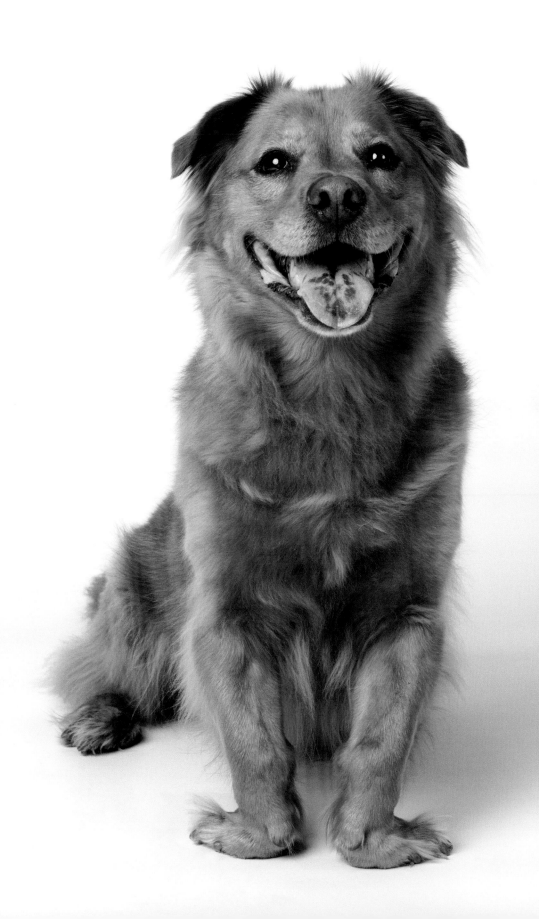

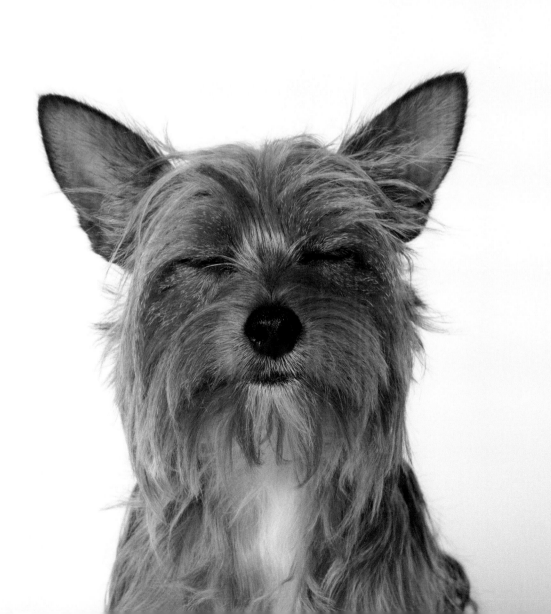

Birdy CHIHUAHUA / YORKIE
Little dog, big snuggles

Lottie CHIHUAHUA / TOY FOX TERRIER / ITALIAN GREYHOUND

Living her best life, one hug at a time

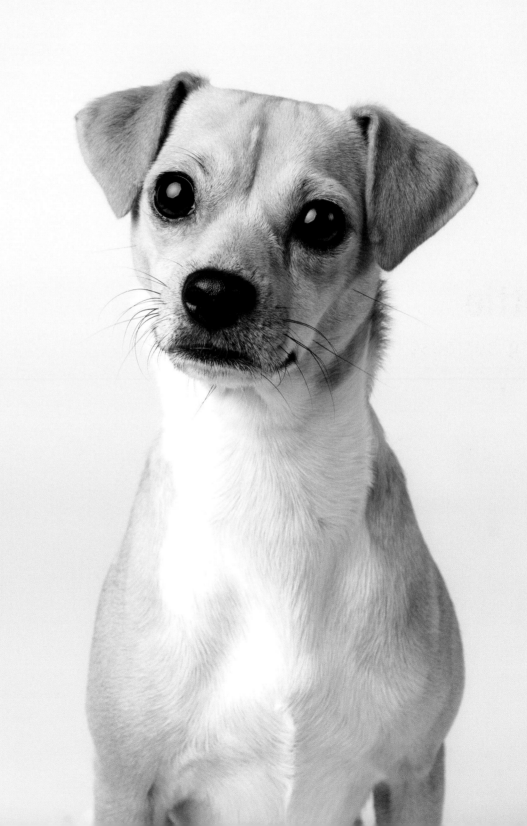

Pippa JACK RUSSELL / YORKSHIRE TERRIER

Lizard lover

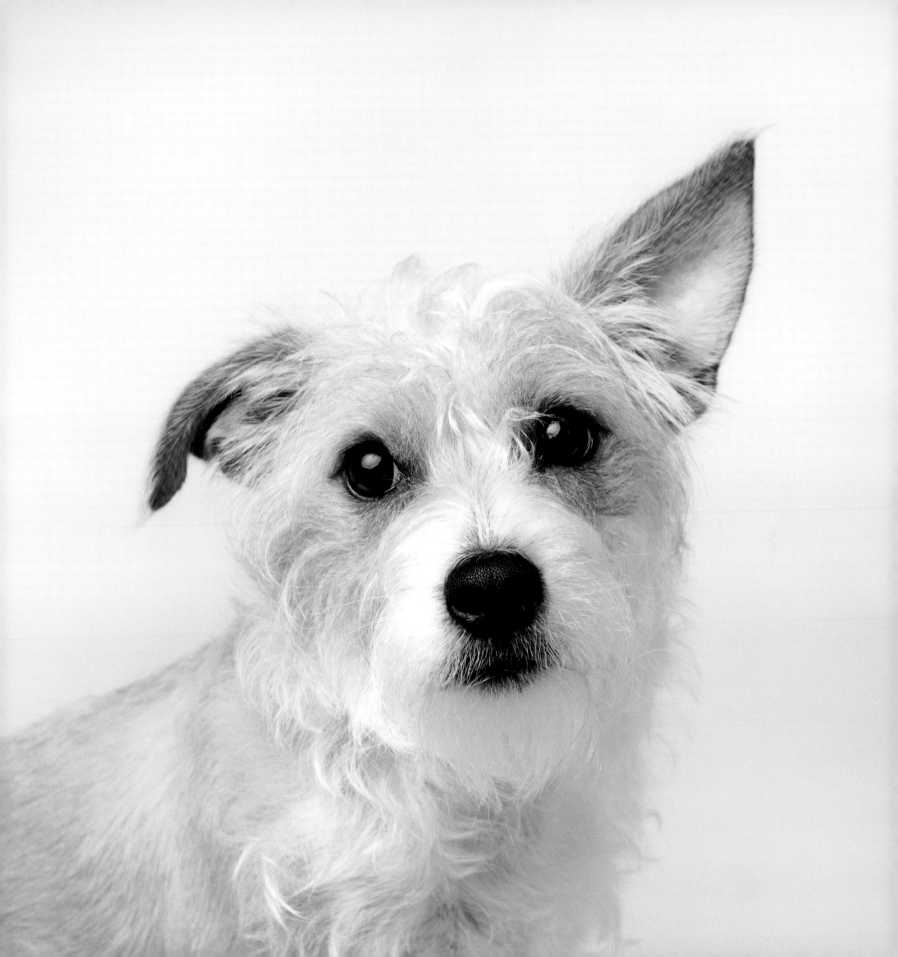

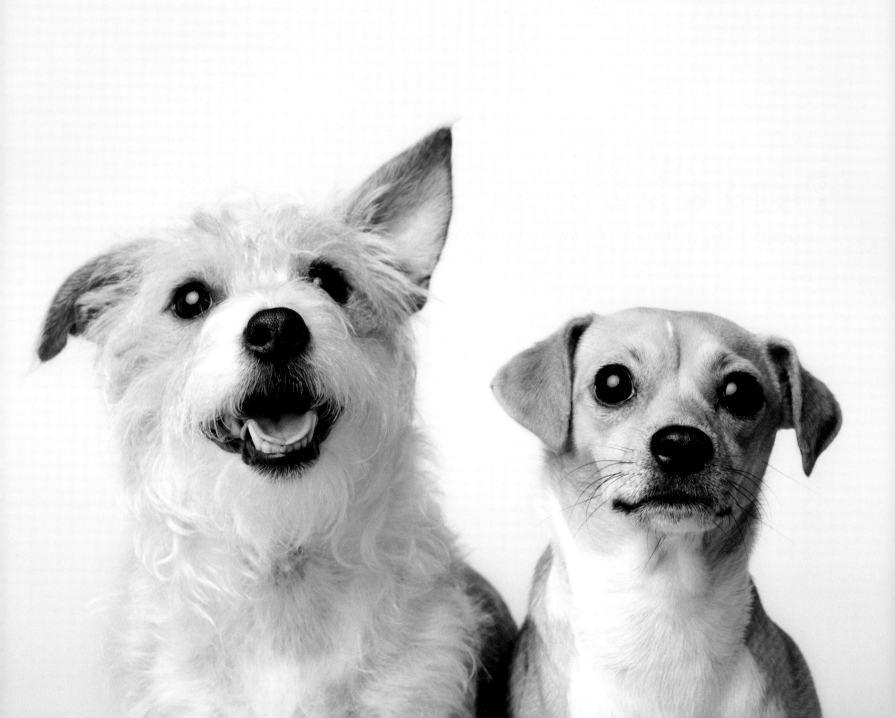

Pippa & Lottie

Adopted together after becoming besties in their foster home

Charlie HUSKY / MALAMUTE / JACK RUSSELL TERRIER / WELSH TERRIER

Wishes he could be a sled dog

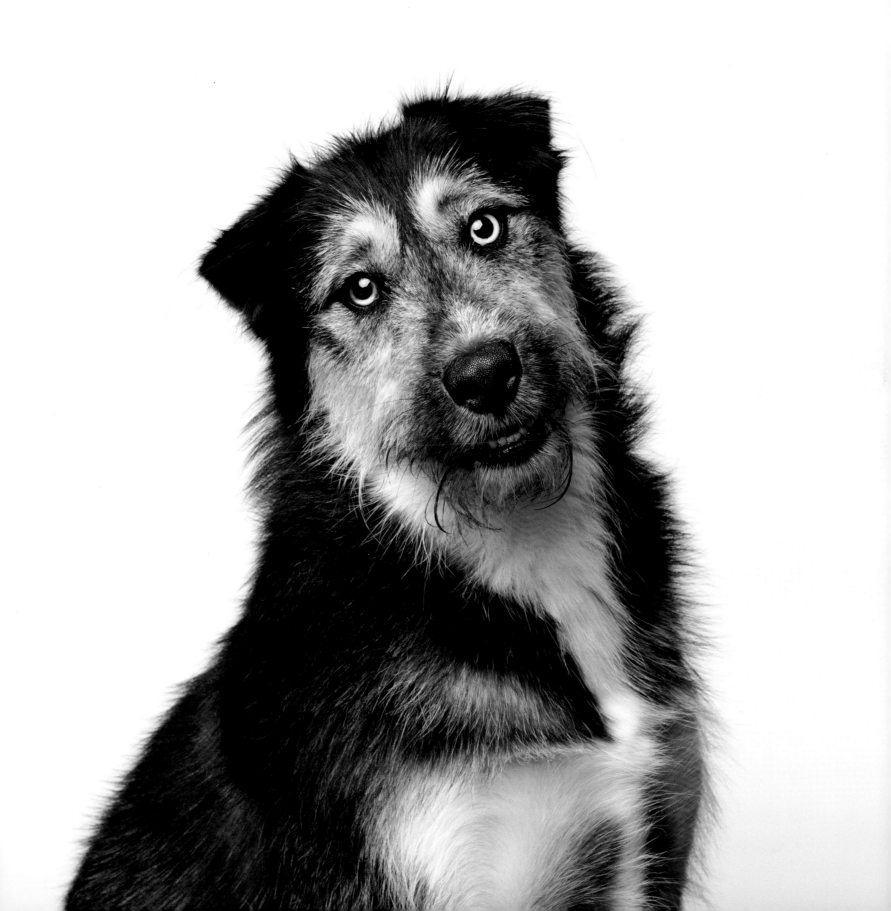

Roux RAT TERRIER / BOSTON TERRIER / CHIHUAHUA

Barks at the wind and her own farts

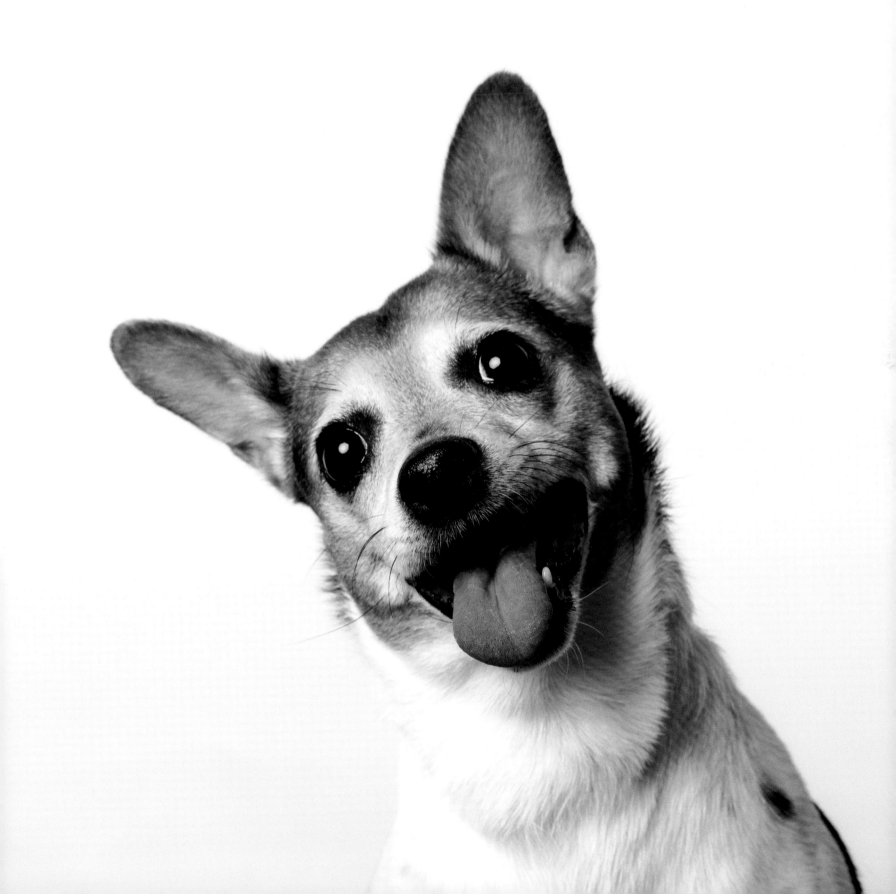

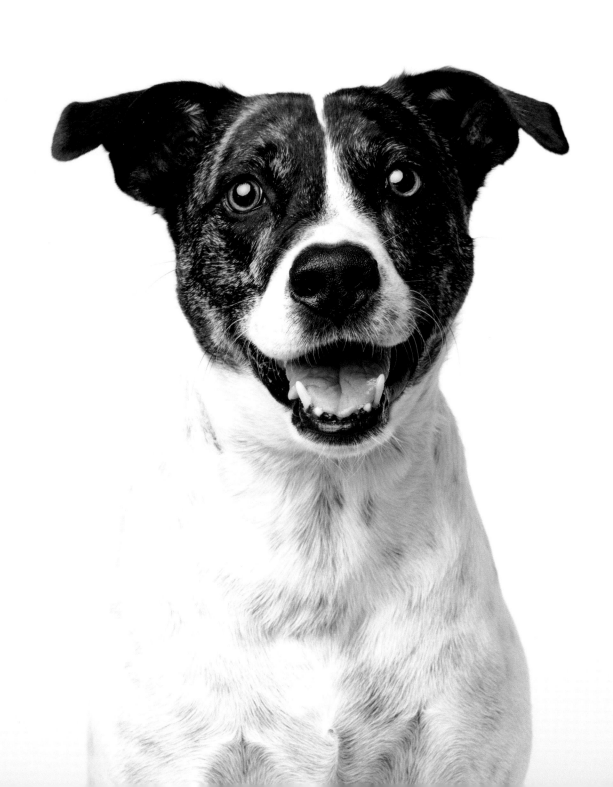

Dinker DANISH FARM DOG / CATTLE DOG / DALMATIAN / PIT BULL

Has trained her humans to be very obedient

Basil <small>PAPILLON / SHELTIE</small>

Is a chimera: genetically two different dogs, a 1-in-10,000 chance

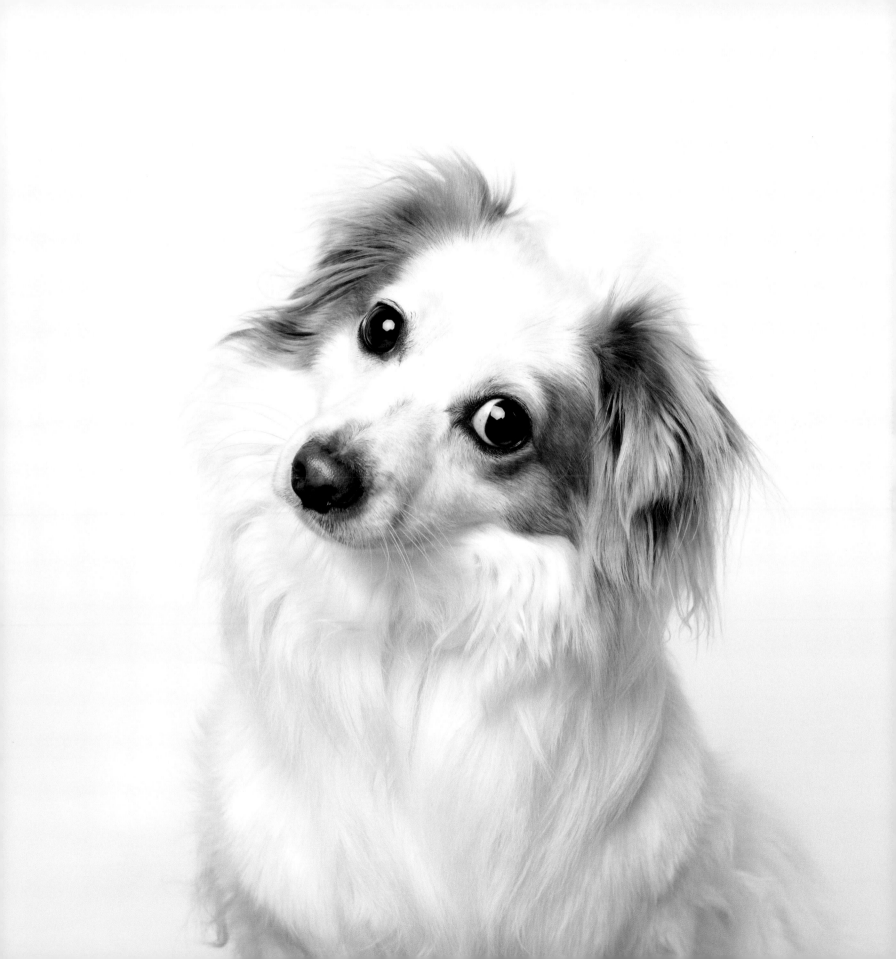

Jolene BEAGLE / CHIHUAHUA

Gives her humans a fifteen minute warning before mealtimes

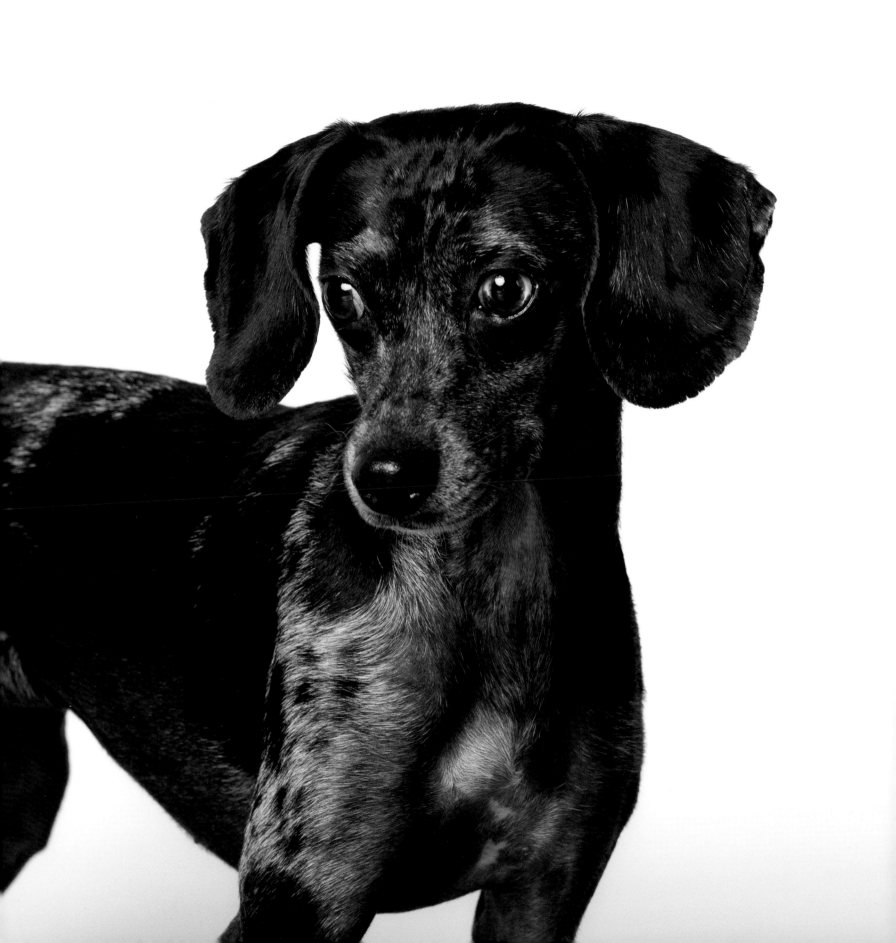

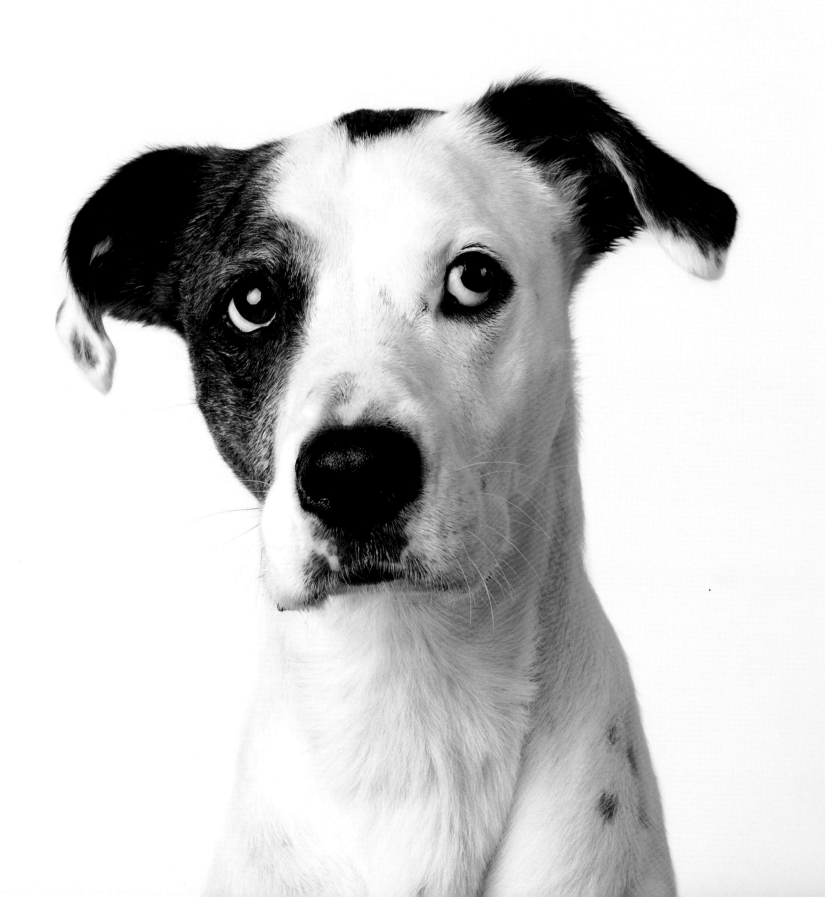

Zoe BOXER / LABRADOR RETRIEVER / POINTER / CATAHOULA LEOPARD DOG

Holds her dad's whole hand in her mouth when he gives her scratches

Bertie DOBERMAN / CATAHOULA / SHEPHERD / SCHNAUZER

Loves to swim and be a foster mom to rescue puppies

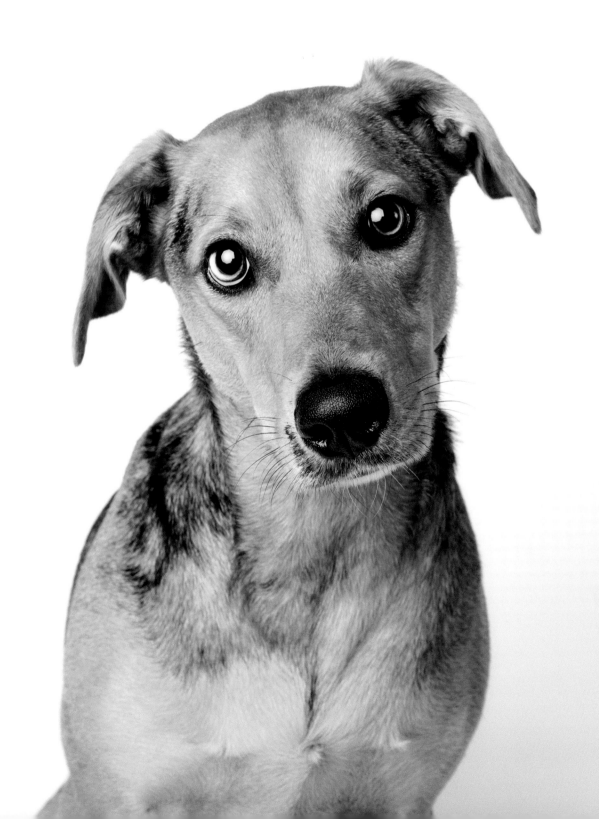

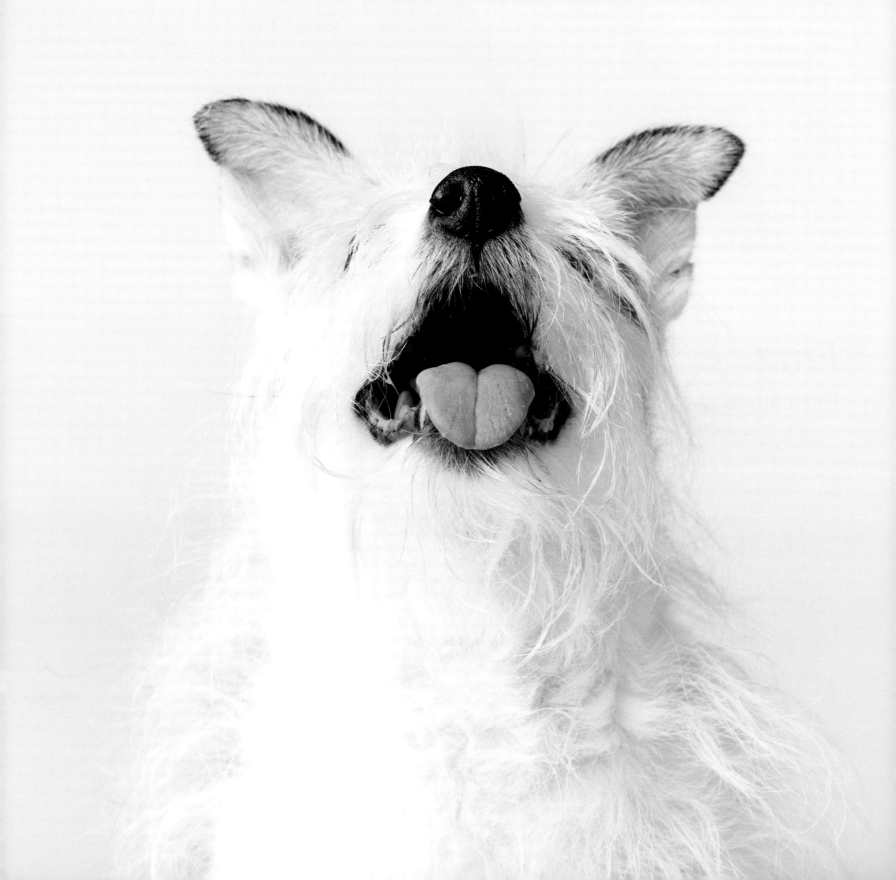

Frizz BICHON FRISE / SHELTIE

Basically a cat obsessed with zucchini

Lulu PIT BULL / RETRIEVER

Carries her stuffed animals everywhere, even on walks

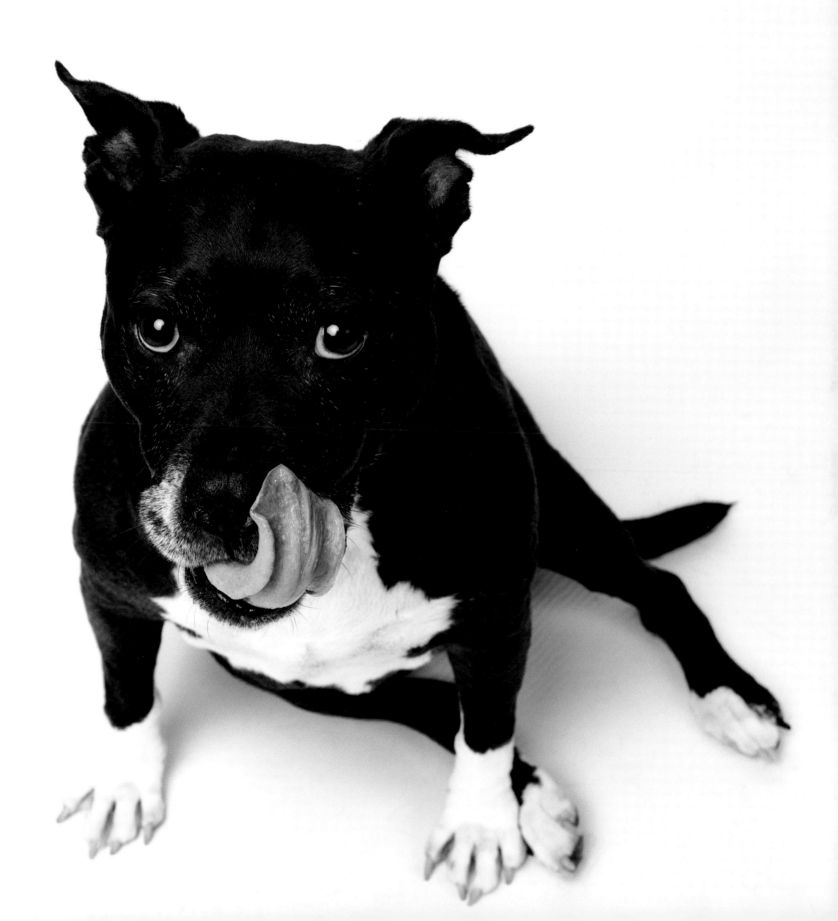

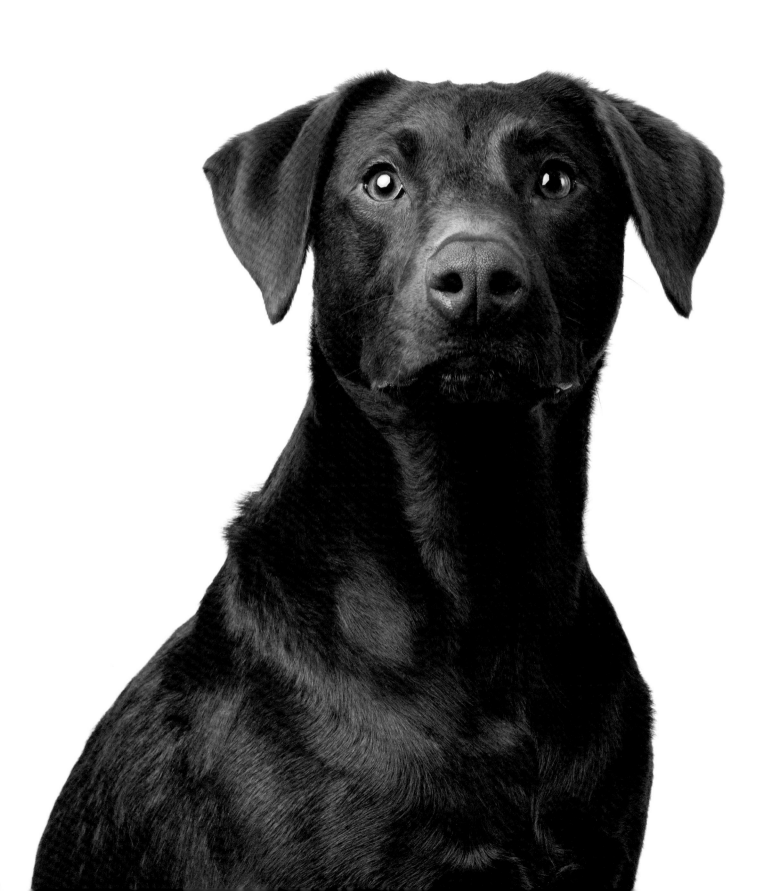

Wally CHOCOLATE LABRADOR / TERRIER

Only eats if his humans sit with him while he dines

Bodhi DACHSHUND / CHIHUAHUA / BLACK LABRADOR / TERRIER

Likes to bury himself in blankets and make his humans worry that he might be suffocating

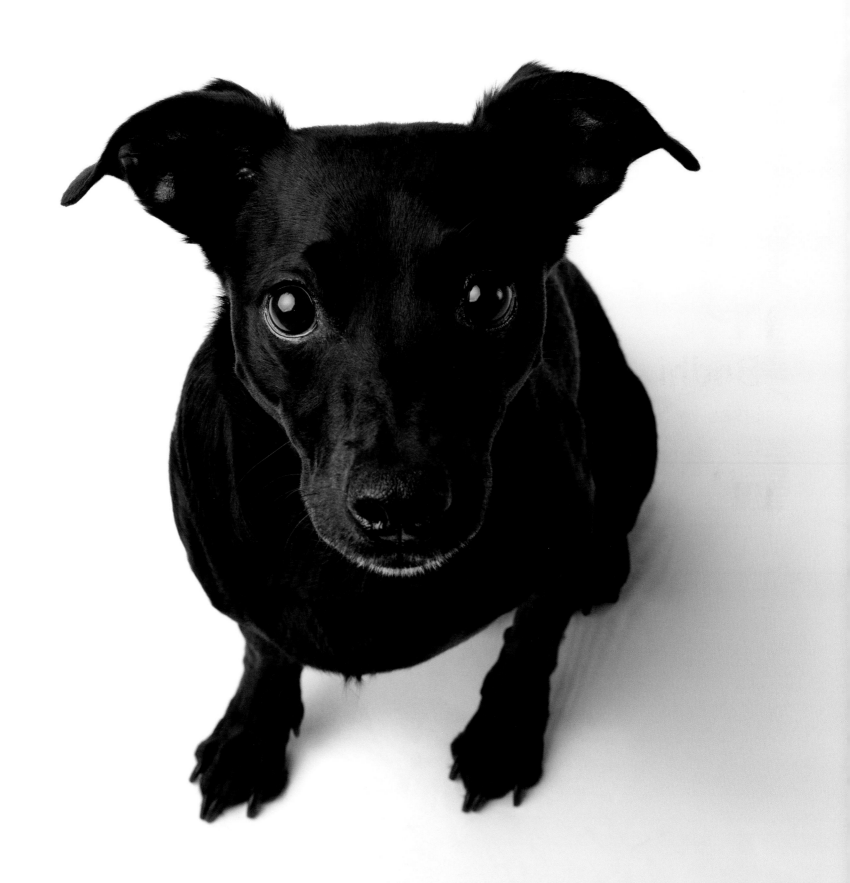

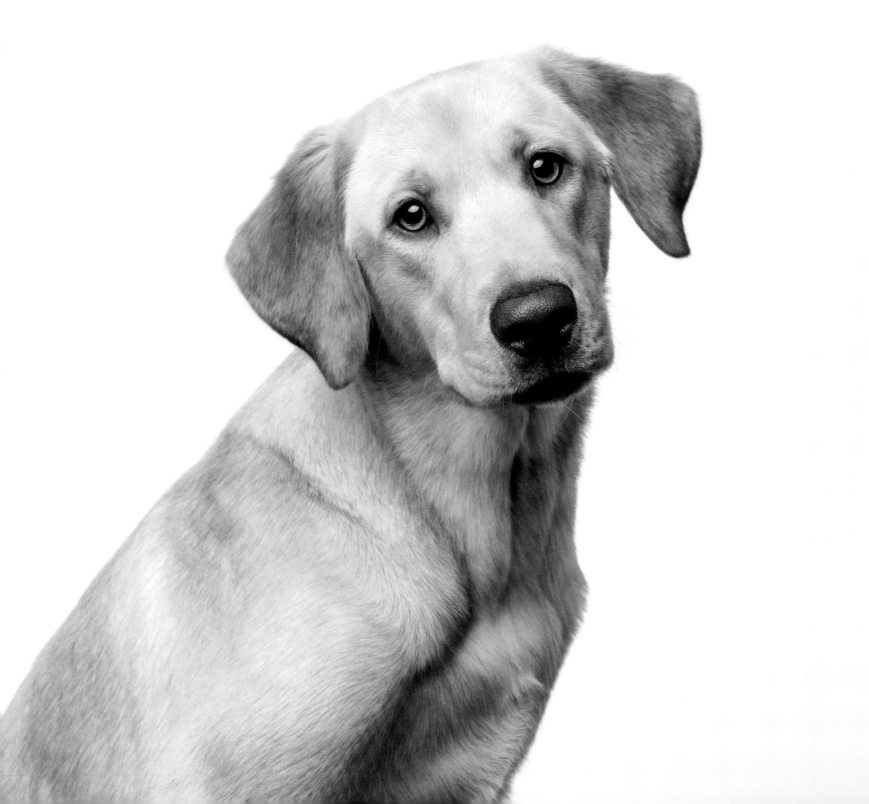

Aurora LABRADOR RETRIEVER / AUSTRALIAN SHEPHERD / AUSTRALIAN KOOLIE

Bathes her (unwilling) dog and cat siblings in kisses

Fifi WIREHAIRED GERMAN POINTER / CHESAPEAKE BAY RETRIEVER

Invites guests who stay past sunset to leave

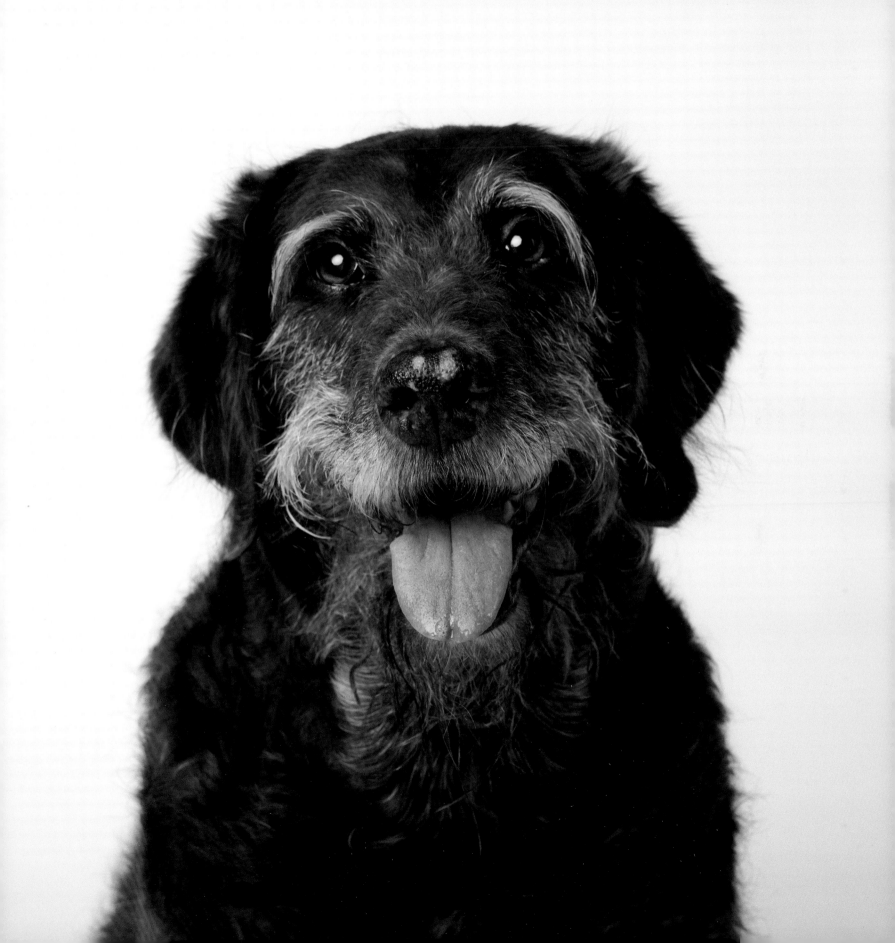

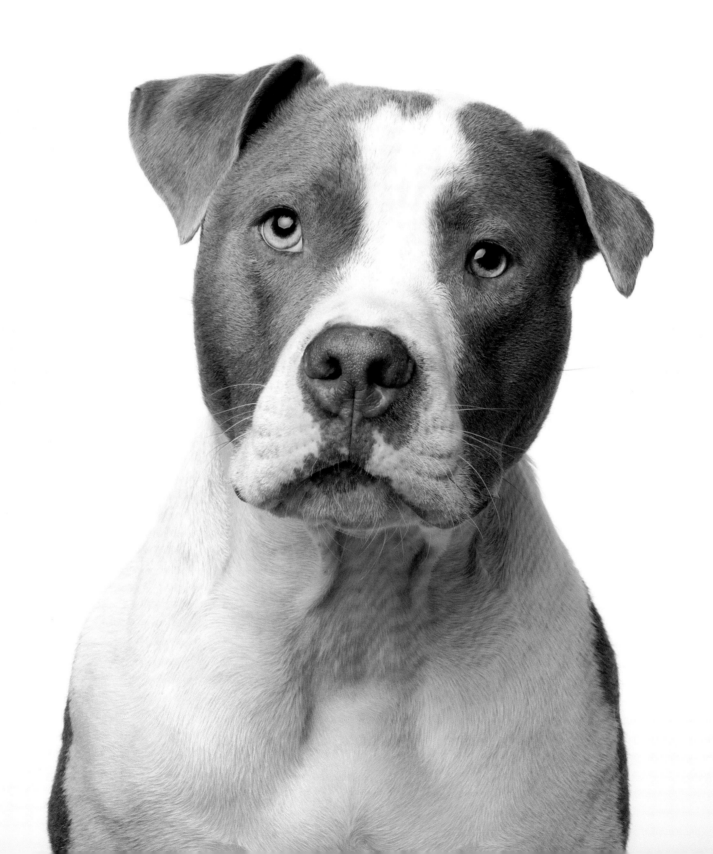

Blue PIT BULL TERRIER / STAFFORDSHIRE TERRIER

Swims out so far at the beach his mom worries he won't come back

Meeko <small>CHIHUAHUA / COYOTE</small>

Purrs like a cat

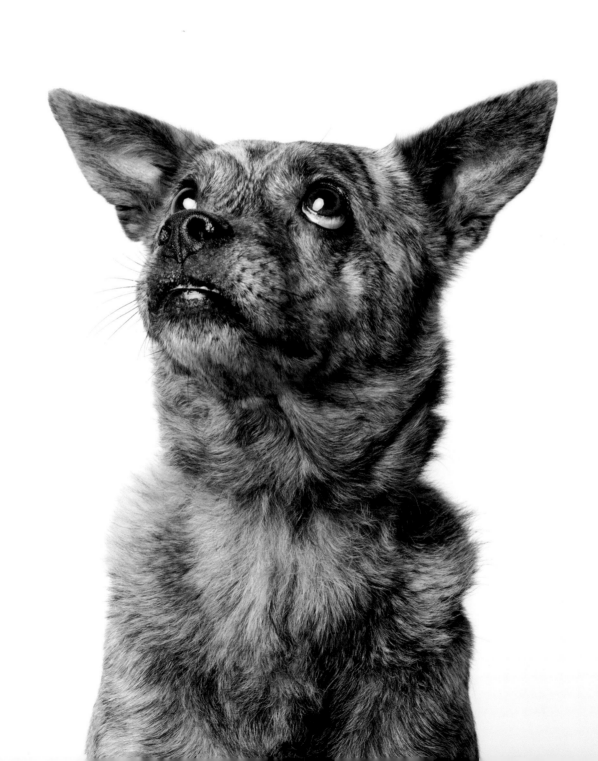

Emi AMERICAN PIT BULL / WHIPPET

Sleeps between her humans at night and shoves herself into the middle of hugs

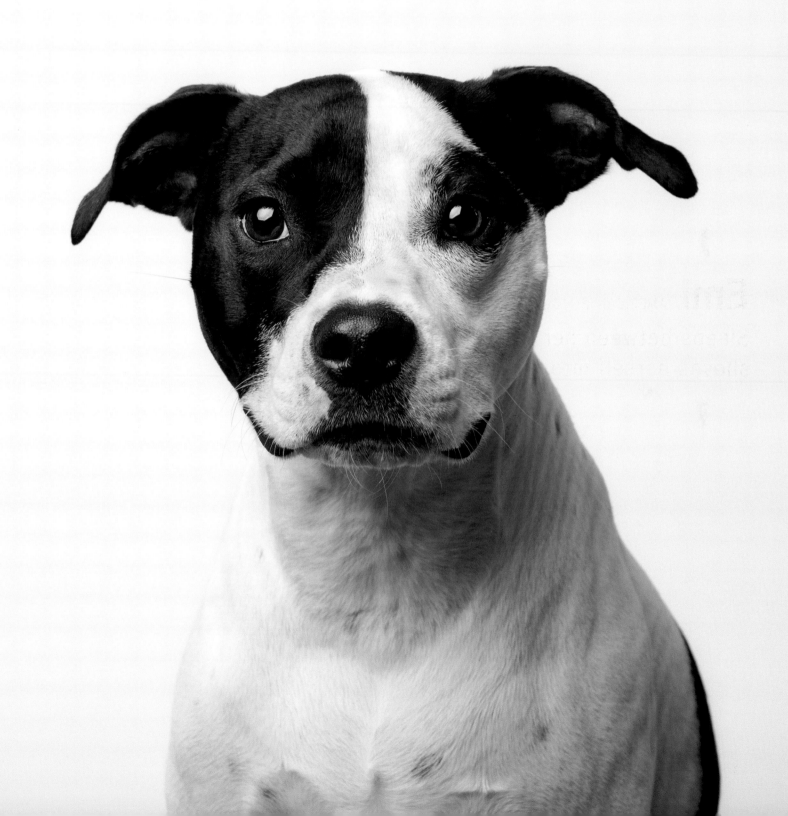

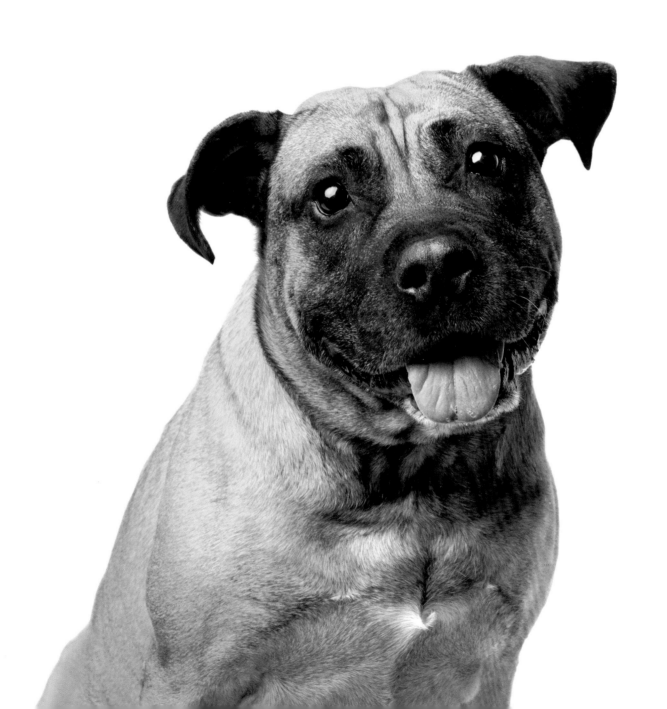

Layla NEAPOLITAN MASTIFF / PERRO DE PRESA CANARIO / BULL MASTIFF

Loves to harmonize (aka whine simultaneously) with her new baby sister

Izzy AMERICAN PIT BULL / AMERICAN BOXER

Gently paws you away when she's done cuddling

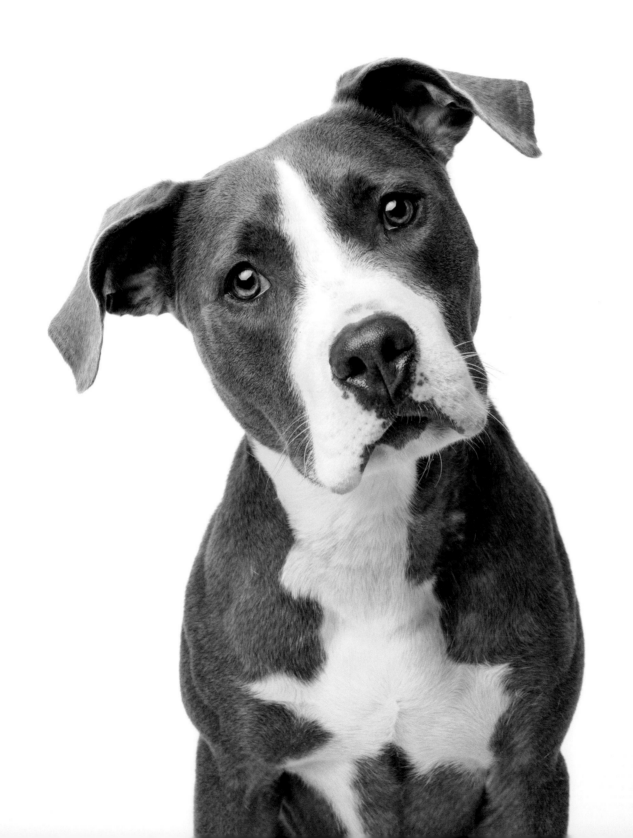

Suki CHIHUAHUA / POMERANIAN / PAPILLON

Occasionally walks on two legs just for fun

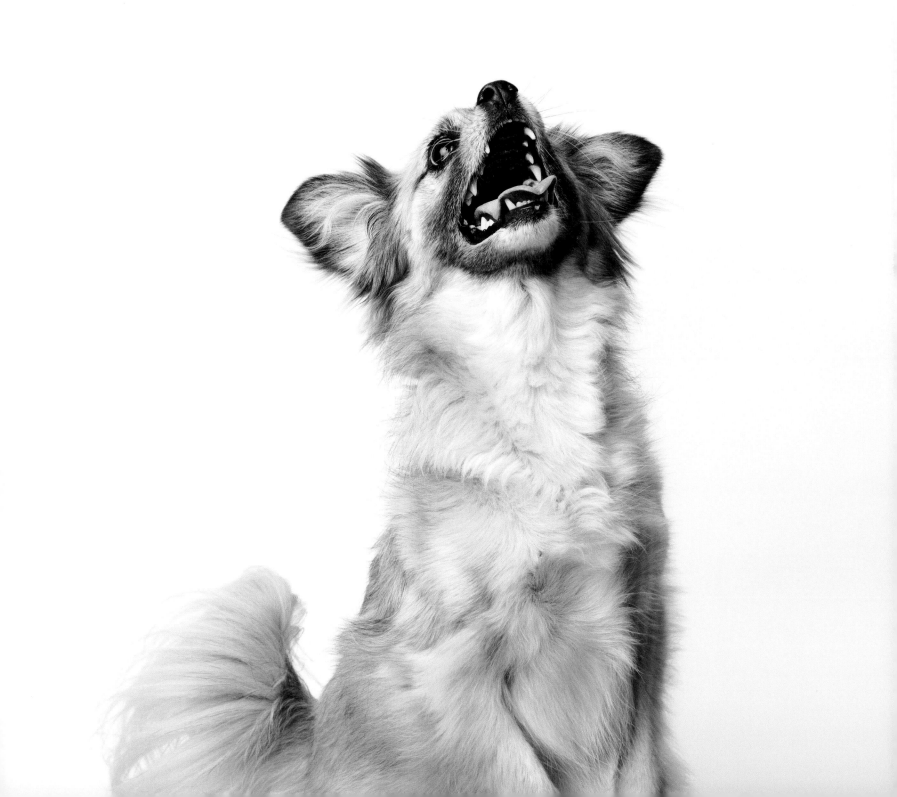

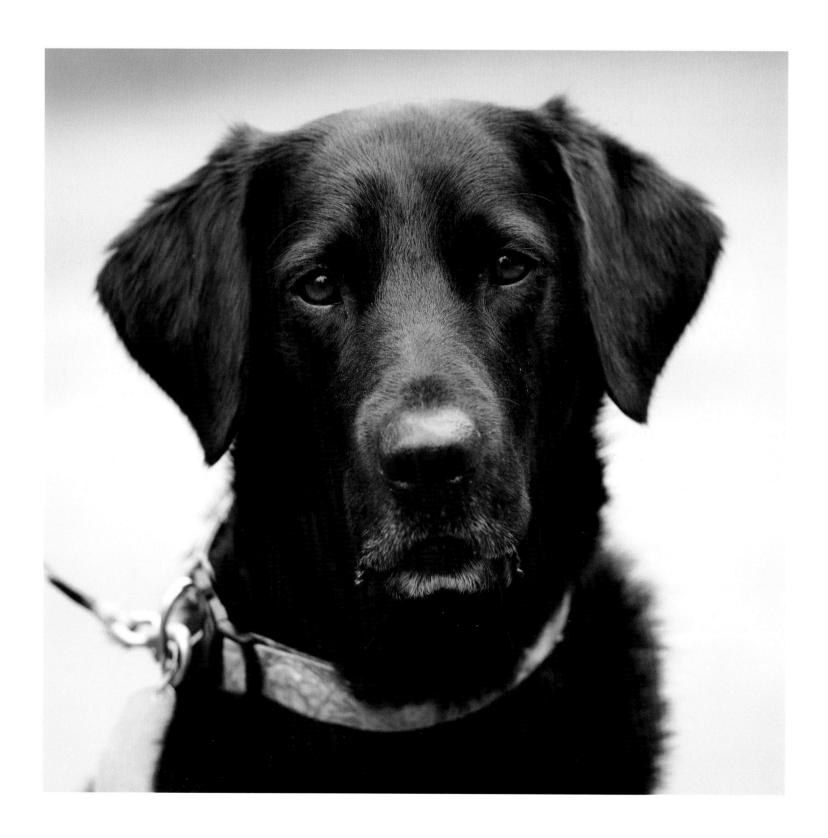

Duke & Jack

Never underestimate the power of a furry friend.

For natural dog people it doesn't take much convincing to continue adopting even after our faithful companions cross over the rainbow bridge. It's not always so easy for the elderly to adopt, for obvious reasons. As Jack Hazard was approaching his 90th birthday, his old beloved companion died and within months Jack was having his heart valve replaced; not a likely candidate for adoption approval at most animal rescue facilities. After nearly seven decades of owning bird dogs and rescues, John, Jack's only son and loyal hunting partner, knew that was just what Jack needed to distract him from the pitfalls that often accompany the elderly. After contacting several dog rescues, John found the perfect match through a local lab rescue. Duke had been surrendered by a family no longer able to care for him and was living with a foster family at the time. John and Jack were interviewed and met Duke to see if they would be a good match. Through perseverance and consistency Jack recovered from his surgery, and Duke became part of the family. It didn't take long for their bond to solidify. Through repetition and routine, they practice the daily art of hiding, throwing and retrieving the bumpers. The joy they both receive from lessons perfected is visible to anyone who has ever seen them in the park. While adopting a rescue is a lifetime commitment, age has many factors in that decision. But at ninety-four years old, this dog owner uses his responsibility as a gift to stay active, live healthy and revel in small accomplishments. To see these two together, it's irrefutably evident that they are soulfully connected as pure and simple as breathing.

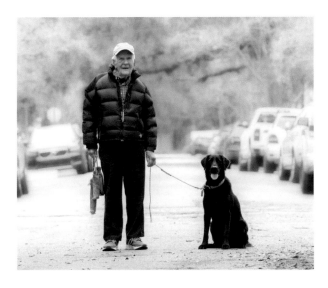
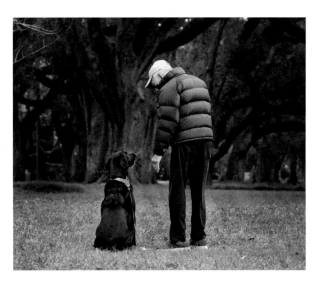

Phoebe Cakes

I scoured every bulldog adoption site for months to no avail. Adopted, taken, or reserved was stamped across each ad. I'd almost given up until one day I saw picture of a tiny bulldog with a wide smile and a bubble gum tongue. One look into those big brown eyes peering back at me, I knew I had found something incredibly special. My long search was over. This is our story...

Hi! My name is Phoebe Cakes. I'm a special needs bulldog living the good life in New Orleans. I love peanut butter and long car rides. My early life wasn't so easy but that all changed when I met my foster mom, Clare, at the New Orleans Bulldog Rescue. She helped me get back on my feet and on my way to finding my furever home. I took my time. I sniffed, I snorted and turned up my wet nose. I'd almost given up until the day I met Michelle. She was the twenty-first person to apply for my adoption. I now call her mom, but she calls herself Lucky #21.

She loves writing about me, and I love lounging, treats and wagging my tail!

Love, Phoebe

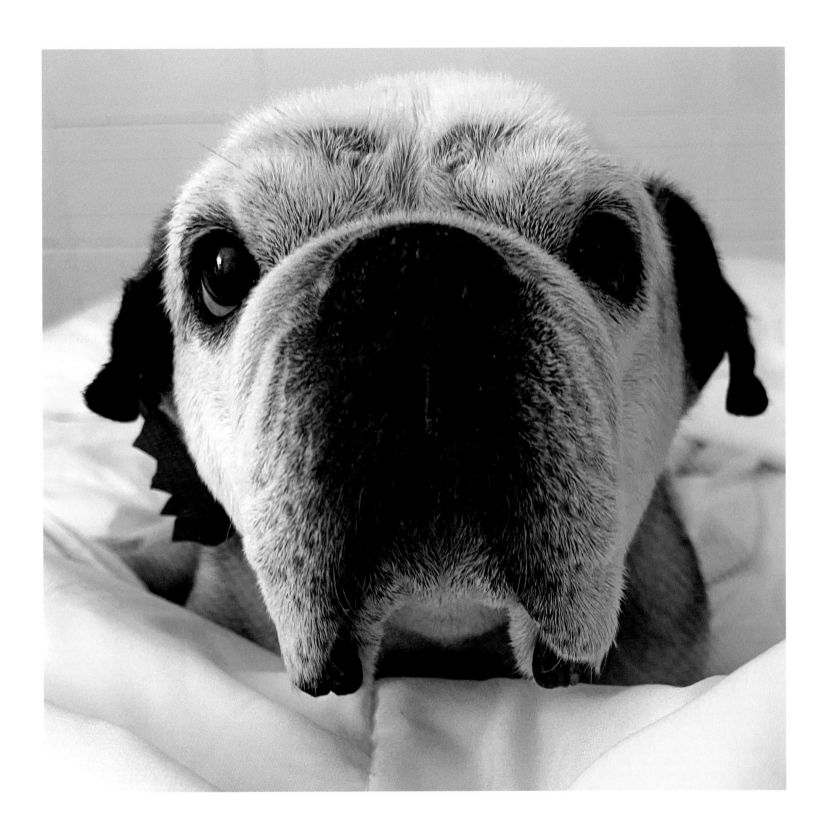

Index

adores big dogs, and when a friend told her of the litter being adopted out, she couldn't resist taking Bean!

BEAR *(page 47)*: Age 2 – Bear came from a Great Pyrenees + Siberian Husky rescue in Virginia. He was so unique that the rescue owner gave Bear to his friend, Dylan, as a birthday present. He is enormous, stubborn, and very loved!

BEBE *(page 99)*: Age 7 months – Bark and Roll Rescue worked with Santa to bring Bebe to her furever family in 2020! The only thing her two human sisters wanted for Christmas was a puppy. They say few things compare to how happy Bebe gets when you rub her belly or play ball with her!

BELLA & PUPPIES *(page 76-79)*: Bella's foster mom saw Animal Rescue New Orleans post a pregnant dog that needed a safe place to have her puppies, so they decided to foster Bella (and eventually her puppies) until they could be adopted out. Bella went into labor just three days after arriving in her foster home. Her foster mom said her family has loved getting to know Bella and watching the puppies grow, change, and develop distinct personalities. Bella and all her puppies have since been adopted!

BENJI *(page 181)*: Benji had lots of anxiety when he was first adopted from a shelter, and his adopter was going to return him to the shelter for nipping. Luckily a friend of hers offered to take him, and that friend has become Benji's mom since 2014! She says he just needed time and patience to feel safe and secure. It took months of work and tons of love and encouragement, but he eventually calmed down and adjusted to life with his new mom.

BERTIE *(page 213)*: Age 1 – Bertie's mom was surrendered, pregnant, to a rural shelter, and Take Paws Rescue pulled her to be fostered so she could have her pups in a quiet place. Bertie's human mom is best friends with Bertie's foster mom, and she says when they met her, they knew they weren't letting her go!

BIRDY *(page 192)*: Age 10 months – Birdy was rescued by a mom who is a huge dog rescue advocate. They usually foster and find homes for their rescues, but they had to keep Birdy! She is named after their New Orleans restaurant, Birdy's, and her human brother and sister can't go to bed without their Birdy snuggles.

BLUE *(page 226)*: Age 3 – Blue's human mom found him on a street corner when he was a tiny puppy - she opened her car door and he hopped in. She took him to the vet because he had a puncture wound on his cheek that you could see through. The vet said it looked like he'd been used for fighting. He was emaciated and injured, but his new mom, Ashley, nursed him back to health and ended up keeping him!

BOGIE *(page 12)*: Age 1 – Bogie was the runt of fifteen siblings, and the Take Paws Rescue transporter didn't think he would survive to make it to their foster home. He did and won over their hearts with his resilience! They ended up adopting Bogie and recently threw a birthday party for him –thirteen of his littermates were in attendance!

BODHI *(page 221):* Age 4 – Bodhi's human mom adopted him in Los Angeles. He was the only dog in the facility that was not barking, just looking around and watching everything. His big brown eyes sucked her in, and she took him out to see how he did outside of the shelter. She says he just lit up and came to life! He is so well-behaved and just wants to play around people.

BOSS *(page 48):* Age 8 months – Boss and his sisters were found abandoned in a box on a Mississippi hunting camp property, covered in fleas. Someone found them and took them to Rescue Revolution in Houma, Louisiana. Boss' human mom, Adriana, opened Petfinder one day and saw his sweet face – she was on the phone and applying for him within two minutes. She picked him up less than twenty-four hours after he was posted!

BUTTERS *(page 119):* Age 1 – Butters was found on the side of a highway with an extension cord around her neck like a leash. A Good Samaritan picked her up and found a foster home for her. Her foster mom brought her into a veterinarian and mentioned she was looking to place her in a home – and a vet tech jumped at the chance

to adopt her. (If Butters had been a foster, Olivia would have photographed her and then adopted her – Butters is that perfect.)

CASH *(page 110):* Age 10 – Cash was found on the streets in Baton Rouge by his human dad, a college student who hid Cash from his parents for six months. Finally, the secret came out, but no one could resist Cash – he was officially adopted as part of the family ten years ago. He has survived a little cancer scare, and still acts like a puppy!

CANE *(page 125):* Age 2 – Cane was found with his eight littermates under a house in rural Louisiana. No one knows how long they had been there without their mom, but Take Paws went to rescue them, finding homes for all nine puppies!

CELESTE *(page 26):* Age 2 – Celeste was found in Slidell, Louisiana, when she followed a rescue dog and his foster mom home on a walk. She was a skinny little puppy with pointy ears that were too big for her body! Her human parents met her at an adoption event when she put her paws on her future dad's shoulders like a hug. She

is polite and rambunctious, and always reminds her humans to find joy!

CHARLIE *(page 201):* Age 4 – Charlie is a Cajun dog, found running around the streets of Lafayette, Louisiana by a farmer. He was taken to Take Paws Rescue in New Orleans and adopted by his mom, Maggie, a veterinarian. He now lives in Michigan and LOVES the snow!

CHARLIE *(page 105):* Age 7 – Charlie was rescued as a tiny puppy from rural Louisiana. Her owners kept her tied up outside, where she cried all night. Her furever family began "fostering" her seven years ago, and it's safe to say she's a permanent, beloved member of their family now!

CHARLIE WATTS *(page 157):* Age 1– Charlie Watts was rescued through Take Paws Rescue in April of 2020, just at the start of the global pandemic. He has been the best company during lockdown and beyond!

CHEYENNE *(page 142):* Age 2 – Cheyenne was only about nine months old, and her time at the St Tammany Animal Shelter was up – she was scheduled to be euthanized at 4 pm.

Her human mom saw her picture on a social media post by Once Upon a Tail Rescue and agreed to foster her...three years ago. Cheyenne is now her wonderful foster fail!

CHICORY (*page 61*): Age 3 – Chicory's human mom, Melissa, started out fostering Chicory, who was her 48th foster dog! Chicory got along with the family's other two senior pups, and Melissa decided she needed to be their 3rd dog!

CLOTILE (*page 175*): Age 3 – Clotile's human parents found her on Petfinder and could see her sass through the computer screen! She was at a rescue in Baton Rouge, and they immediately drove to adopt her. She's the tiniest member of their family, but she rules the household!

COUYON (*page 95*): Age 4– Couyon, his mom, and his seven siblings were rescued from a construction site in New Orleans East. Couyon was fostered by a volunteer at Animal Rescue New Orleans, then found his furever home; his future parents loved him the moment they laid eyes on him!

DANNY RAND (*page 85*): Age 10 weeks – Danny Rand and his puppy brother, Matt Murdoch, were found abandoned with their mother. Their other littermates had died, and the two living puppies were covered in fleas and maggots. They were rescued by Take Paws and an amazing foster volunteer. They are true survivors!

DINKER (*page 204*): Age 6 – Dinker came from a high kill shelter in West Monroe, Louisiana. Her human dads saw her on the Internet and knew she was for them! They immediately rescued her from euthanization, and she has rescued them right back, giving them so much love and joy.

DOMINO (*page 66*): Age 12 – Domino came from an accidental litter: a neighbor's dog became pregnant by a stray dog. The neighbor took in the stray and adopted out the puppies!

DOUGLAS (*page 148*): Age 4 – Douglas was rescued from the SPCA in September 2019. His human parents had looked around and finally got to Douglas' kennel. He ran out and gave them huge puppy dog eyes and a million kisses, and they've been inseparable ever since!

ELVIS (*page 58*): Age 3 – Elvis' first rescue family was a trial run; they were on the fence about keeping him. Then their son and daughter-in-law came to visit, and they fell head over heels for Elvis! By the end of the trip, Elvis had a new furever family who was buying a pet carrier to fly him home!

EMI (*page 231*): Age 2 – Emi's parents knew that she was the dog for them when they saw her smiling big in a photo on the Take Paws rescue website. They went to meet her at her foster home and took her home the next day for a "trial run" – but they've never thought twice about keeping her! She beat a heartworm positive diagnosis and is now happy and healthy.

EVIE (*page 158*): Age 1 – Evie's future mom was looking for a small dog, but also an athletic one. Evie was at a shelter in rural Louisiana and as soon as her mom laid eyes on her, she knew Evie was the perfect dog for her. Evie is sweet, docile, and exactly what her mom was looking for: a less energetic, pocket-sized rescue German Shorthaired Pointer mix!

EVIE *(page 19):* Age 7 – Evie's human mom, Stephanie, was a foster for Catahoula Rescue South Central and saw Evie's photo posted on a Texas shelter's social media page. She was only a year old and a stray. Stephanie figured someone would adopt her right away, but a few weeks later Evie's photo came back up with a euthanasia date just a few days out. Stephanie drove to get Evie and take her home to New Orleans, and the rest is history!

FABIO *(page 169):* Age 8 – Fabio's family adopted him from Animal Rescue New Orleans when he was three years old. After seeing his picture with the name "Fabio", they fell in love. He now has a human sister and is expecting another sibling!

FANCY *(page 102):* Age 9 – Fancy was found wandering the streets alone with no hair, bronchitis, and heartworms. After some rehabilitation with Blue Tails Rescue, Fancy found her new family and is living her best, spoiled life! She loves attention and cuddles and insists on a strict bedtime (as she's an elderly lady).

FERB *(page 15):* Age 8 months – Ferb and his littermates were almost left at a rural kill shelter, in a cardboard box, at only two weeks old. Their mom had gotten mastitis and refused to nurse, and the owners didn't want to bottle-feed. Luckily the box of puppies was intercepted by a rescue coordinator, who took the babies and arranged for their bottle feeding. Ferb went with a couple of his siblings to his human mom, who bottle fed them for weeks until she found families for them... except for Ferb. He had already found his family!

FIFI *(page 225):* Age 14 – Fifi had been with a family since she was a puppy, and they abandoned her when she was eleven years old – just moved with their other dog, kids, and cats, left Fifi with a neighbor "for a couple of weeks", then told him to take her to the pound when he asked when they were coming back for her. He didn't want to do that to a senior dog who had never been in a shelter, so he found her a new human mom who absolutely treasures her. Her new mom, Shawna, says she's never been a moment's trouble and has the best personality. Fifi is now living the spoiled, good life she deserves in her retirement!

FILÉ *(page 41):* Age 1 – Filé was surrendered by his owner when he was just eight months old. Take Paws Rescue pulled him, knowing that pit bull mixes fill shelters in the South, and it can be hard for shelters to find good homes for all of them. He was then adopted by his furever family!

FINN *(page 179):* Age 3 – Finn's mom was pulled from a shelter in rural Louisiana by Nola Lab Rescue. She was pregnant, and Finn ended up being the runt of the litter. His human parents began fostering him, and quickly decided they couldn't part with him!

FRIZZ *(page 214):* Age 14 – Frizzy was basically a missed connection on Craigslist. Her human mom started the process of adopting her but missed out when another family's application was approved first. Lucky for her, that family didn't work out, and Frizz ended up with her furever mom!

GATEWAY *(page 90):* Age 5 – Gateway was found as a stray in New Orleans East and left at a vet clinic. The clinic treated him for heartworms and neutered him, and after three months with no luck adopting him out, they asked Animal Rescue New Orleans for help. Gateway is a sweet, good boy!

GIGI (*page 72*): Age 14 – Gigi was rescued from the St. Charles Animal Shelter when she was a year old. She loves riding on the pontoon boat and jet ski. She was a wild child at first, but now as the oldest in their family of dogs, she has helped train her three younger sisters and has become the most loyal pup.

GUMBO (*page 89*): Age 4 – Gumbo's human parents were living in Washington, D.C. when they saw a shelter picture of Gumbo: a very chunky puppy passed out in his food bowl. They went to meet him and were told, "If you're looking for a dog to run with, this is not that type of dog." They immediately knew he was the dog for them, and he's been enjoying a life of lounging, lazy walks and plenty of treats since.

GUNNER (*page 20*): Age 6 – Gunner's human mom adopted him from the Jefferson Parish Animal Shelter to be a brother to her other pup, Max. She says he seemed very calm at first, but then they found out he was sick – they got him healthy, and he's been a character ever since!

GRACIE (*page 184*): Age 2 – Gracie was rescued from a shelter outside of Lake Charles, Louisiana. She hadn't spent much time indoors but made herself right at home with her new family. Their elderly and difficult two dogs miraculously accepted Gracie into their lives before passing away. With an abundance of grace, young Gracie helped her family members through the process of parting with their seventeen-year-old pups. She is an old soul who happily suns herself on the front porch without dreaming of wandering off.

HAZEL (*page 126*): Age 12 – Hazel's human mom, Claire, saw her running through their yard when Hazel was three months old. At first glance, she thought Hazel was a chicken! She went outside to investigate and found a tiny puppy with huge ears. Claire found her original owner, but they didn't plan to keep her, so they gave her to Claire, who is a veterinarian; Hazel couldn't have found a better family!

HOLDEN (*page 130*): Age 6 – Holden and his sister were found alone after the Baton Rouge flood of 2016. They were rescued by Zeus' Rescue and his future mom, Grace, saw a picture of him and thought he looked exactly like

a larger version of their tiny dog, Huey (also featured in MUTTS)! He quickly outgrew the predicted thirty pounds and is now taller than his humans when he stands on his back legs.

HOLLY (*page 36*): Age 1 – As a tiny puppy, Holly was abandoned at a nice woman's house in rural Louisiana. That woman couldn't keep her, so she posted on social media to see if anyone wanted her before she took her to a shelter. Holly's future mom, Liza, drove out to get her and found her on the back porch of a small house with other dogs, cats, and chickens. The woman gladly passed her off to Liza, who drove Holly straight to her furever home.

HUEY (*page 75*): Age 9 – Huey was rescued after someone dumped him on the Huey P. Long Bridge in New Orleans. Zeus' Place brought him to an adoption event at the mall, and his future mom saw a little four pound guy run up to her, and she was hooked! They put in an application for Huey that night and picked him up a few days later.

INDIE *(page 136):* Age 12 weeks – Indie was abandoned at a Tractor Supply in rural Louisiana with her sister. They were both tiny puppies, skinny, full of fleas and worms. Take Paws took them in and nursed them back to health, and when Indie's mom saw her picture, she knew that she had to adopt her! She's the perfect mellow, fluffy sidekick.

IZZY *(page 235):* Age 1 – Izzy is an adoptable pittie mix who was found in a mall parking lot, wandering alone and emaciated. Animal Rescue New Orleans pulled her from the Jefferson Parish Animal Shelter and since her photo shoot, she has been adopted!

JACKIE *(page 51):* Age 1 – Jackie was the runt of her litter, and her siblings were stepping and sleeping all over her before she was adopted. She loves her naps – her human family carried her to a Mardi Gras parade when she was still small, and she didn't even open her eyes to look around!

JASPER *(page 32):* Age 11 – Jasper, the inspiration for this book, was named "Horse" at the shelter in Hattiesburg, Mississippi, where he was brought in as a stray. He was only ten months old and severely underweight at seventy pounds. My sister was going to adopt another dog from the shelter, and I tagged along. I saw Jasper and fell in love with his huge feet and goofiness. He was on the euthanasia list, so I took him home. He is the best dog I've ever had.

JOE *(page 7):* Age 6 – Joe's human parents met him at a New Orleans restaurant, Dat Dog, who was hosting an adoption drive with Zeus' Rescue. They had their first dog with them, Opie, who was very particular about other canines – but gave his nod of approval to Joe!

JOLENE *(page 209):* Age 6 – Jolene was found alone in the woods by a Good Samaritan near Shreveport, Louisiana. The woman who originally adopted her discovered quickly that she had too much energy for her older dog, who was very nervous around the new pup. Luckily, her cousin was able to take her in, and Jolene found her furever family!

KUZKO *(page 63):* Age 1 – Kuzko was found on the side of the road as a tiny ball of floof with his mom, who appeared to be a German Shepherd. He was fostered at a doggy daycare so he's excellent with other dogs, including his doggy sister, River! His human mom says Kuzko can be a fuzzy handful at times, but he's been the best addition their family could have gotten!

LANA *(page 23):* Age 2 – Lana's human foster mom, Leslie, worked for Animal Rescue New Orleans. ARNO pulled Lana, heavily pregnant, from the shelter right before Hurricanes Delta and Zeta. Leslie took her home to foster her during the storms, and there Lana gave birth to eleven, yes eleven, big, healthy puppies. The litter stayed with Lana until they were old enough to be adopted out, but Leslie couldn't let go of sweet Lana, and kept her!

LAYLA *(page 232):* Age 7 – Layla was adopted by her human dad, Michael, when she was a puppy at a PetCo adoption event. He took her home for an overnight stay and never brought her back! A month later the shelter called and asked him to fill out the adoption paperwork and pay the $65 fee – Michael says it's the best $65 he's ever spent!

LEMON *(page 82):* Age 9 months – Lemon's moms adopted her from a litter through Take Paws Rescue.

They brought their other dog, Mo, to meet the litter, and they all three agreed that little Lemon was the one for them. They love her sweet disposition and jet black hair.

LILLIE (*page 24*): Age 6 months – Lillie was found wandering around New Orleans at about five months old. After her stray hold, Animal Rescue New Orleans pulled her and her future human mom, Katherine, applied to foster her. As soon as Katherine picked her up, Lillie looked at her as if to say, "I think I'm home finally"... and turns out she was!

LOTTIE FAYE (*page 195*): Age 1 – She and her foster sister, Pippa Pearl, met and became inseparable at a foster home through Second Chance Dog Rescue. Her human mom saw her picture and fell in love with Lottie's smile and Pippa's sweet face, so she inquired about both of them. The rescue couldn't imagine separating them, so now they're now living their best lives in Covington, Louisiana!

LUCILLE (*page 161*): Age 8 – Lucille was found on the side of the road and rescued by the Louisiana SPCA. She was adopted from the shelter by her human mom, who was impressed to find Lucille can open and close doors and knows so many tricks!

LUCY LOU (*page 69*): Age eight weeks – Lucy's mom was surrendered, pregnant, and then pulled from the shelter by Take Paws Rescue. Lucy Lou was so fluffy and adorable with her eye mask, her human mom applied to adopt her the second she saw her online!

LUCKY (*page 183*): Age 13 – Lucky was surrendered as a senior dog to Jefferson Parish SPCA by his long-term owners. His human mom, Leslie, swooped in and rescued him. She says he came with a lot of medical issues, but none that could stop her from loving and spoiling him!

LULU (*page 217*): Age 11 – Lulu came from Clarksville, Tennessee. Friends of her current mom, Heidi, were deploying to Japan and didn't want to put Lulu through the lengthy quarantine process. Heidi offered to take her, and so Lulu's family drove her down to New Orleans the next day! Now she gets lots of love and walks in the Big Easy!

LULU (*page 42*): Age 9 – Lulu was found as a tiny (almost newborn) puppy in a trash can in Mobile, Alabama. She was rescued by someone who luckily heard her in the trash can and was willing to help her and then find her a wonderful home!

MAGGIE (*page 170*): Age 12 weeks – Maggie was brought in as a stray to a shelter in Baton Rouge, Louisiana, when she was only four weeks old. No one knows what happened to her mom or littermates. Her owners adopted her from the shelter and named her Magnolia, after the state flower of Louisiana.

MAHLI (*page 53*): Age 7 – Mahli's first owner sadly had to give her up and posted her on social media to try to re-home her. Her new mom, Toni, saw her friend's post and thought Mahli was adorable. Toni and her husband took Mahli in, and now they can't imagine their little family without her!

MALIBU BARBIE (*page 112*): Age 6 – Malibu Barbie's owner was looking for a "small" female dog to adopt after her previous dog passed away. She found Malibu at the Louisiana SPCA through Petfinder and fell in love with her right away. Malibu was heartworm positive, but together they made it through treatment, and now Malibu Barbie is living the princess life!

MANGO *(page 71):* Age 2 – Mango's human family had been fostering dogs through Take Paws Rescue, and when they got Mango, they knew they had to keep him! His adorable looks and his funny, stubborn, and sweet personality were impossible to resist!

MAPLE *(page 96):* Age 3 – Maple was found as a stray in Opelousas, Louisiana. Animal Rescue New Orleans helped clear some space in the rural shelter by pulling some dogs for foster. An ARNO volunteer met Maple one day and fell in love with her shy but sweet, silly, and affectionate personality. Maple was adopted into her furever home two weeks later!

MARDI *(page 129):* Age 3 – A family found him at a construction dump site as a puppy, only a few weeks old. He was injured and sick, but they fell in love with him and nursed him back to health. They already had two dogs and three kids, so they adopted him out to his furever mom, Cillie, and Mardi has been her sidekick ever since!

MARMADUKE *(page 39):* Age 5 months – Marmaduke's future mom met him at a friend's house, where he was being fostered with two other puppies. His foster mom convinced her friend that Duke was the puppy for her!

MATT MURDOCH *(page 86):* Age 10 weeks – Matt Murdoch and his puppy brother, Danny Rand, were found abandoned with their mother. Their other littermates had died, and the two alive puppies were covered in fleas and maggots. They were rescued by Take Paws and an amazing foster volunteer. They are true survivors!

MAYDAY *(page 150):* Age 12 – Mayday was rescued by Captain Hunter Davis when he was stationed in San Antonio with the US Air Force. As a pilot's pup, she was named for the rescue call of aviators. Mayday returned the favor a year later after her dad was gravely injured. She was his constant companion by his wheelchair and helped him learn to walk again.

MAX *(page 57):* Age 2 – Max's human family found him through Take Paws Rescue when they were searching for a new best friend for their son, Coulter. Their previous pup left them too soon from lymphoma, and Max's markings reminded them of their beloved boy. They met him and quickly fell in love with Max and those beautiful eyes. They say he has a most unique personality and an even more curious palate that surprises them every day, as they've yet to find an object he will not sample.

MEEKO *(page 229):* Age 7 – Meeko was adopted from the Louisiana SPCA as a puppy. His owner is active with pet rescue and couldn't resist the little brindle puppy with the underbite!

MIKA *(page 8):* Age 1 – Mika was part of a litter surrendered to Take Paws. Her owners saw her picture on social media and applied to adopt her. Her littermates all have multi-colored eyes!

MOOSE *(page 31):* Age 1 – Moose sat in a rural shelter for three months, and while people inquired and called about him, no one ever came to meet him. They seriously missed out. Thankfully, Take Paws pulled him from the shelter, and he was up for adoption at the time of his shoot. Moose is a gentle giant, really the sweetest, most precious boy. When I saw his

photo, I knew I wanted him in the book – he was the very last dog photographed for *MUTTS*. I was very tempted to take him home myself!

MUNCH *(page 187):* Age 7 months – A teenager found Munch in a box outside of a drugstore. He brought him to a rescue, where the owner tried talking her daughter into taking Munch. The daughter said no, but then her mom showed up at her door to "show her how cute he was"...and Munch never left!

MURPHY *(page 191):* Age 10 – Murphy was adopted at a shelter in Chattanooga, Tennessee, in 2011. He moved to New Orleans with his human dad the next year, and there they both met Mom! He now lives with his dad, mom, and new human baby brother!

OPIE *(page 154):* Age 6 – Opie had been adopted and returned twice before he was nine months old. Zeus' Place pulled him from the shelter, and his new human family adopted him several days later. He had severe separation anxiety, so they had to teach him to be alone, starting with ten seconds at a time! Opie is much better now, though he still prefers to have his whole family home.

PAISLEY *(page 29):* Age 6 – Paisley's human mom, Chelsea, was in college and working at a vet clinic when Paisley's foster mom brought her in. Chelsea instantly knew that Paisley was for her! She adopted her, and they've been together ever since. Chelsea was also my dog handler for *MUTTS* and was so excited to bring Paisley in for her photo shoot and show off her sweet girl!

PENELOPE *(page 122):* Age 3 – Penelope was in five homes before finally finding the right fit with her furever family. (She was a total dream at her photo shoot, so we have no idea why those first five homes didn't work out!)

PETRIE *(page 133):* Age 5 – Petrie's human mom met him when a friend of hers was fostering Petrie through Animal Rescue New Orleans. She sat down in a big chair and Petrie wedged himself between her and the arm of the chair. She says it was love at first snuggle!

PHINEOUS *(page 188):* Age 2 – Not much is known about his past before he ended up at a kill shelter in Baton Rouge, but Dante's Hope Pet Rescue

pulled Phineous from the shelter to work on finding him a family. His furever family adopted him from the rescue and can't imagine life without him!

PICKLE *(page 135):* Age 6 – Pickle was a timid stray that followed her human mom home one day. They took her in while searching for an owner, but after three days, she escaped from the backyard. They looked for her for days, and then one day her mom was meeting a client in a totally different part of town. The client was trying to save a stray dog that turned out to be... Pickle! Her mom, Hannah, knew it was fate, and Pickle has been a part of their family ever since.

PIPPA PEARL *(page 197):* Age 1 – She and her foster sister, Lottie Faye, met and became inseparable at a foster home through Second Chance Dog Rescue. Her human mom saw her picture and fell in love with Pippa's sweet face, who reminded her of her childhood best friend. She also loved Lottie's picture and inquired about both of them. They're now living their best lives together in Covington, Louisiana!

RAKI (*page 81*): Age 11 – Raki was surrendered by his owner when he was around five years old. His new mom, Athena, adopted him from the Louisiana SPCA. He's an old man who cuddles with his family members only when he thinks they're asleep.

RHEA (*page 120-121*): Age 2 – Rhea lived her first six weeks in a dirt hole covered by a piece of plywood. The mom was an eight-month-old basset hound, and the dad was a neighbor's Catahoula who jumped the fence, resulting in an accidental litter. The basset hound owner finally surrendered the mother and her puppies to Take Paws Rescue, where they were adopted to families.

RICO (*page 153*): Age 1 – Rico's human parents found him a few months after losing their two elderly pups. They saw his picture on a rescue site and fell in love with his floppy ear and skinny legs – they went to meet him and knew he was meant to be theirs!

ROCO (*page 54*): Age 3 – Roco's humans were planning to adopt an English Bulldog, but it didn't work out. The kids were so upset, so they all went to the shelter in Hammond, Louisiana, where they found Roco! They call him their "sweet little baby man" and say he thinks he's an actual baby. He's the perfect dog for them!

ROSIE (*page 11*): Age 3 – Rosie was found tied to a post in Houston, Texas. A rescue advocate in New Orleans drove to get her and find her a family. She spent the first few months in her new home hiding under the bed, but she is slowly coming out of her shell and learning to trust people!

ROUX (*page 203*): Age 9 – Roux was adopted from a Jack Russell rescue in North Carolina. They were just in the nick of time to save her, her siblings, and their mother from being put down. Turns out there's a lot more than Jack Russell in her (check those ears)!

RUBY (*page 141*): Age 9 – Ruby's human mom rescued her at an adoption event with Friends of the Animals of Baton Rouge. Ruby was facing the wall, snoozing, not paying any mind to the noise and chaos around her. Ruby's mom knew she was the one – Ruby even peed on her new mom on the way home, marking her forever.

RUE, MARIGOLD, AND OTTER (*page 163*): Ages 8, 3, and 5 – Rue's human mom met her when Rue was dumped at Birmingham Humane Society, very afraid. Marigold was adopted from the Human Educational Society in Chattanooga a few years later to befriend Rue. And Otter joined the family when his mom was walking to lunch and found him as a tiny puppy!

RUE (*page 176*): Age 12 – Rue came from a kill shelter in Hattiesburg, Mississippi. Her mom, Hannah, wanted to get a sibling for her first dog, Hector and saw her sweet face in a picture online. Her first owners surrendered her because she was "too much", but Hannah says she's just enough! She's kept her moms laughing for over a decade and Hannah says Rue is her soulmate dog.

RUSTY (*page 115*): Age 12 – Rusty's human dad, Hans, was looking for a dog that he wasn't allergic to and visited Zeus' Rescue in New Orleans. Rusty was sitting quietly in his crate, and it was love at first sight!

SAINT LOUP (*page 93*): Age 11 – Saint Loup was adopted from the Louisiana SPCA by her human family

when they were "just looking" at the dogs there. She was four years old and heartworm-positive, but she made it through her treatment successfully. She's great with kids and cats, though not a huge fan of other dogs - but her mom says even saints aren't absolutely perfect!

SHAGGY (*page 145*): Age 3 – Shaggy was adopted from the Jefferson Parish SPCA. He didn't bark for a month after his family took him home. He's become more confident and is extremely emotionally intelligent and empathetic.

SOPHIE (*page 147*): Age 9 – Sophie's human mom was working at a pet rescue in Los Angeles helping them set up adoption events. She noticed that not a lot of people seemed interested in Sophie because she didn't seem interested in people. She just hung back on her chair, lounging. Her soon-to-be human mom, Claire, fostered her, then fell in love and adopted her!

SUKI (*page 237*): Age 7 – Suki was abandoned as a puppy just before Thanksgiving, and there were no rescues with room to take her. Her mom Nicole saw a shared post on social media and agreed to foster her – and she soon became a permanent member of the family!

SULA (*page 107*): Age 3 months – Sula's human parents saw her on the Take Paws Rescue site and filled out the adoption application on a whim –they didn't think they'd get her, they thought she was too perfect! But two days later they met her and an hour after that she was part of their family!

TUCSON (*page 164*): Age 5 – Tucson was rescued through Take Paws when she was two years old. Her family had just adopted an adult, house-trained dog named Batman a few months before, and Take Paws chose Tucson for them when the family was ready for a friend for Batman. Tucson feels very protective of Batman and their mom knows they were meant to be together.

WALLY (*page 218*): Age 4 – Wally was born in a kill shelter and was the runt of his litter. His human mom found him online and decided immediately that she needed to adopt him. He has lots of anxiety, but he is the most loving and affectionate dog she's ever met, and she says he's the greatest blessing in their lives!

WALTER (*page 139*): Age 2 – Walter was adopted through Take Paws Rescue after his family saw a picture of him. They went to his foster home to meet him and then arranged to take him home. Walter now has TRIPLET human siblings at his house, so he has his paws full!

WILBUR (*page 65*): Age 6 months – Wilbur's mom was starved during pregnancy, and Wilbur was born tiny and with sub-aortic stenosis, a heart condition. He was lovingly fostered through Take Paws Rescue and subsequently adopted by his human mom, Traci. Initially his prognosis was not good, and he was expected to live only six months to a year, but he has slowly grown and gotten stronger. His family continues to take care of him and love him for all the time they get with him!

ZOE (*page 210*): Age 8 – Zoe had a rocky start in a home where she didn't get along with another dog and was put up for adoption. Zoe's human dad went to countless rescue events and meet and greets waiting for the perfect fit. He saw Zoe's picture online and it was love at first sight! He is so grateful to Rolling River Rescue for helping him find his best friend.

We are so grateful to these early supporters of MUTTS!

Andrea Hartman

Anne Temple

Bryan, Grace, Samuel
and Elijah Knight

Chelsea Davis

Cooper Schumacher

Corona Kezur

Dr. Robert and Dana Davis

Dylan Kim

Fischer Turner

Hayden P. Smith

Hunter Frazier

In memory of Charlie Shapiro

In memory of Gus Pritchard

In memory of
Hector and Stanley Rachal

Johanna Wilde

In honor of Jack Hazard
& Duke

Leslie Heindel

Lulu Speer

Merja Johnson

Michael Gallaugher
& Willian Sonner

Michelle Dumont

Myra Grey Pritchard Rachal

Patrick Tandy & Bradley Harris

Penny and Lila

Rick M.

Sarah Cosgrove

Shane Guidry

Skylene Montgomery-Payton

The Beducian Boys

The Devilliers

The Hroms

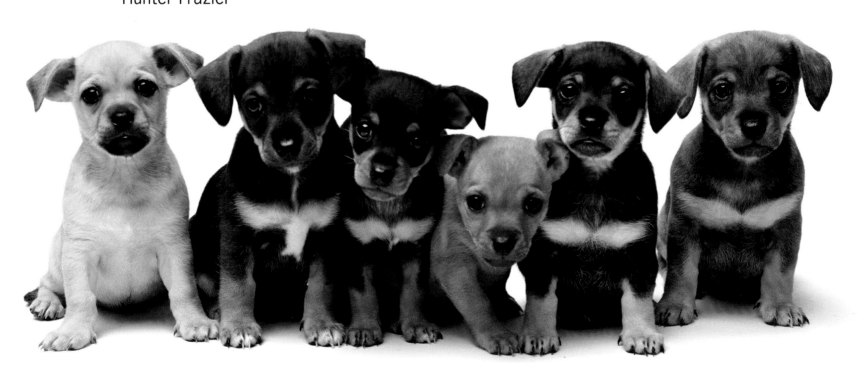

"To be truthful, I always wanted to write about a dog with a story to tell. I think a lot of writers do, the ones who have a soul; the rest are cat people, I suppose."

—**RICK BRAGG,** *The Speckled Beauty: A Dog and His People*

www.susanschadtpress.com

Published in 2022 by Susan Schadt Press, L.L.C.
New Orleans

Design by Doug Turshen with Steve Turner

Library of Congress Control Number: 2022903823
ISBN: 978-1-7336341-7-5

Printed by Friesens in Altona, Canada